■/

GREETINGS! I am Kang, the earthling known as Matt Groening's Emotio[n] Technician. And this is Kodos, the one known as Matt Groening's Emotio[n] Technician's Plasma-grade Weapons Officer. Many have asked, "Where [is] the one known as Matt Groening?" Do not panic, for he is merel[y] undergoing several earth hours of what we call "Past Hugs Regression[."] Rest assured, he is not, I repeat, NOT being made into a tradition[al] RIGELIAN FEAST OF THE IMPURITIES holiday cape!

In his absence, the one known as Matt Groening instructed us to giv[e] you a warning about this television / humor soft-bound publication.
■\

 WARNING: THE BOOK YOU ARE ABOUT TO READ IS FILLED WITH
 CONCEPTS THAT WILL MAKE YOUR TINY EARTH BRAINS RATTLE ABOUT
 IN YOUR SUBSTANDARD CRANIUMS! YOU WILL SIMULTANEOUSLY FEEL
 TERROR, JOY, PAIN, AND INTENSE TITILLATION -- AN EARTH
 CONDITION ALSO KNOWN AS "JUNIOR HIGH." FEAR NOT! KODOS AND I
 ARE HERE TO GUIDE YOU THROUGH YOUR TIME OF CHEMICAL DISTRESS.

■//COMMENCE PSYCHOBABBLE!■//

[F]or centuries, we earthlings have attempted to control our "emotions[."] [W]e have tried to observe the beverage vessel as "half full" rather th[an] "half empty" when, either way, it contained enough sweet-tasti[ng] gelatin pods to lull us into a false sense of security and slowly, b[ut] [h]astily, pickle our inward meats. BOBA-LOVING FOOLS! YOU SHALL BE T[HE] [F]IRST CONSUMED AT THE FEAST OF THE IMPURITIES!!!!!!!!

[B]ut I digress. Desire for emotion control has led our species on [a] [g]lorious quest, from pantheistic religions, to well-bearded emoti[on] [t]echnicians and, finally, to the crowning achievement of earth medic[al] [s]cience: the "self-help" book. Why listen to the clinical "expert[s"] [w]ith their "long-term psychiatric therapy" and their "medications [to] [o]ptimize serotonin so our species may be in peak condition to fend o[ff] [t]he intergalactic pillaging we are so obviously due for?" "Self-hel[p"] [b]ooks teach us that the answers are already inside us and just need [to] [b]e extracted with the help of such mid-brain luminaries as Doct[or] [L]aura, Doctor Phil, and Doctor Sally Jesse. I AM HYPNOTIZED BY H[ER] [F]ASHION SENSE!!!!

[T]hus, Kodos and I have enscribed several of our own "self-help" boo[ks] [a]dvertised throughout this "Fun-Filled Frightfest." You must PURCHA[SE] [T]HEM! For only then can we help you to help yourself to help us he[lp] [o]urselves to a second helping of you.

■/END COMMUNICATION,■/

[T]he one known as Matt Groening's Emotion Technician
■/■

MARTIN'S FOLKTALES FROM AROUND THE WORLD

GREETINGS FELLOW FOLKTALE-OLOGISTS! TODAY WE TAKE AN EXCURSION TO THE FAR EAST AND A CLASSIC STORY FROM JAPAN, THE LAND OF CHERRY BLOSSOMS AND SUSHI... A KINDLY SOUL HAD RESCUED A SPARROW FROM THE CLUTCHES OF A HUNGRY FELINE AND IN RETURN WAS GIVEN THE CHOICE OF TWO BOXES. HE PICKED THE SMALLER OF THE TWO AND, TO HIS DELIGHT, DISCOVERED IT WAS FILLED WITH GOLD AND SILVER. HIS GREEDY NEIGHBOR LEARNED OF HIS GOOD FORTUNE AND CAPTURED THE LITTLE BIRD AND DEMANDED HIS CHOICE OF THE TWO BOXES. HE, OF COURSE, CHOSE THE LARGER ONE AND TO HIS HORROR FOUND IT FILLED WITH...

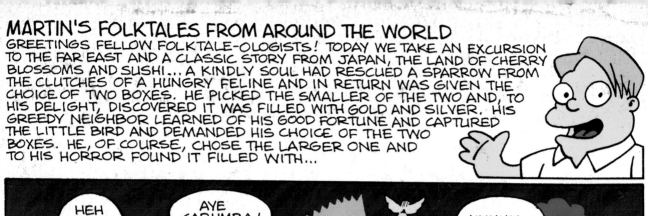

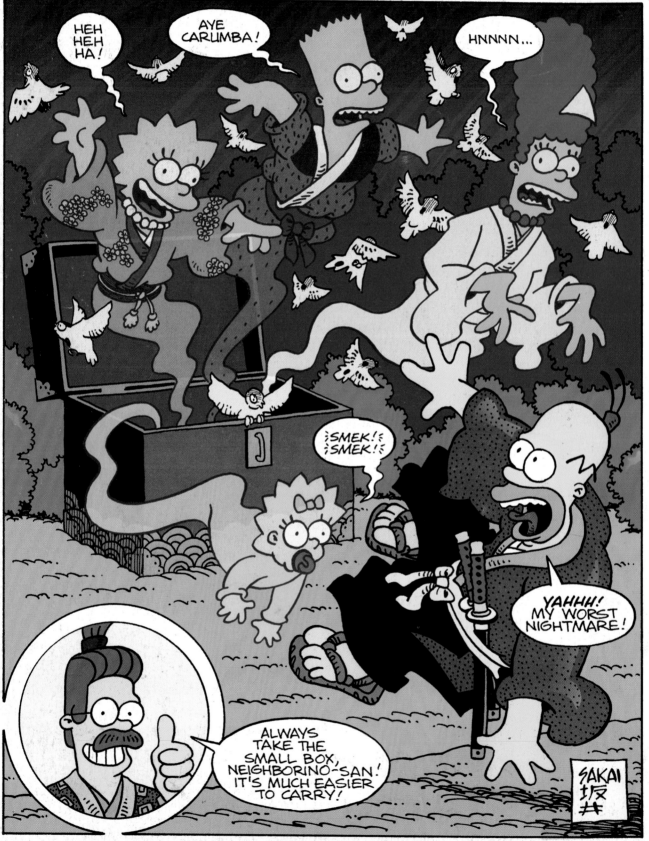

TABLE OF CONTENTS

Menu

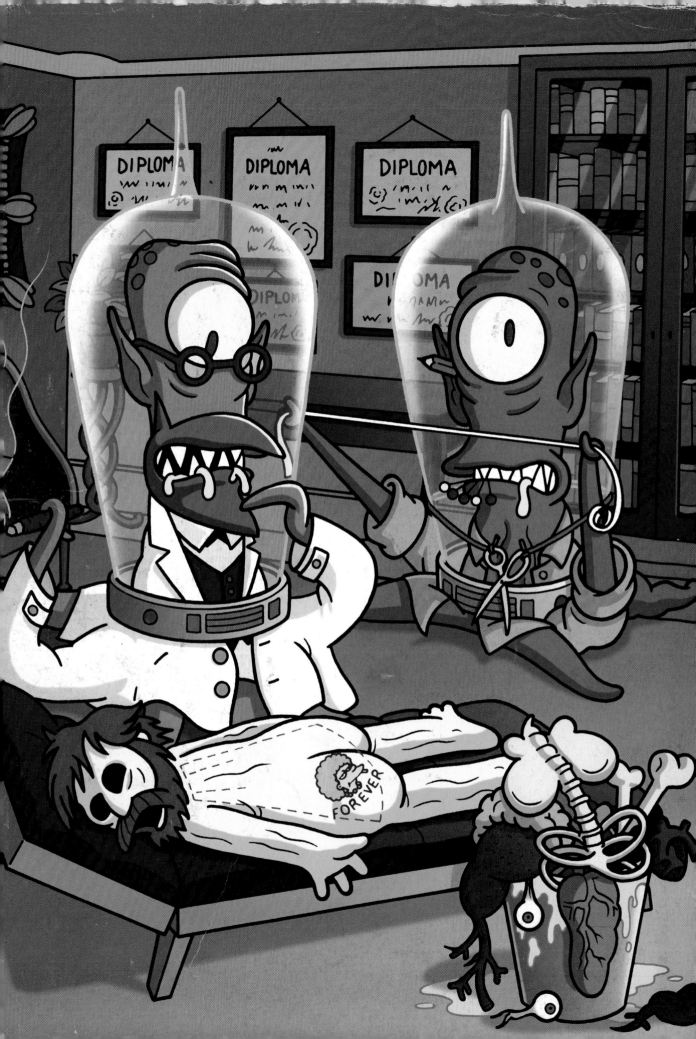

HOMER ERECTUS

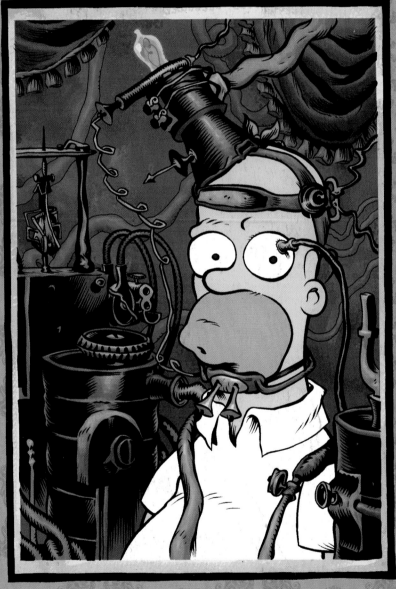

Troy "Not Whistlin'" Nixey	Dave Stewarts and all	Karen Bear Baiter	Bill "Blimey" Morrison	Mischievious Matt Groening
Script & Art	Colors	Letters	Editor	Missing Link

POLAR ICE
CAP. 1875

THE CAMP OF WELSHPEEL AND HENSHAW,
EXPLORERS EXTRAORDINAIRE

Quickly, Henshaw, I'VE NEED OF THE KETTLE.

But I've just made tea.

Damn the tea, man, just fetch the kettle.

I say, Old Bean, did you just say DAMN THE TEA? It's royal blend, you know.

Science before royalty, Henshaw. Just bring the kettle!!

Hmph. Damn the tea, indeed.

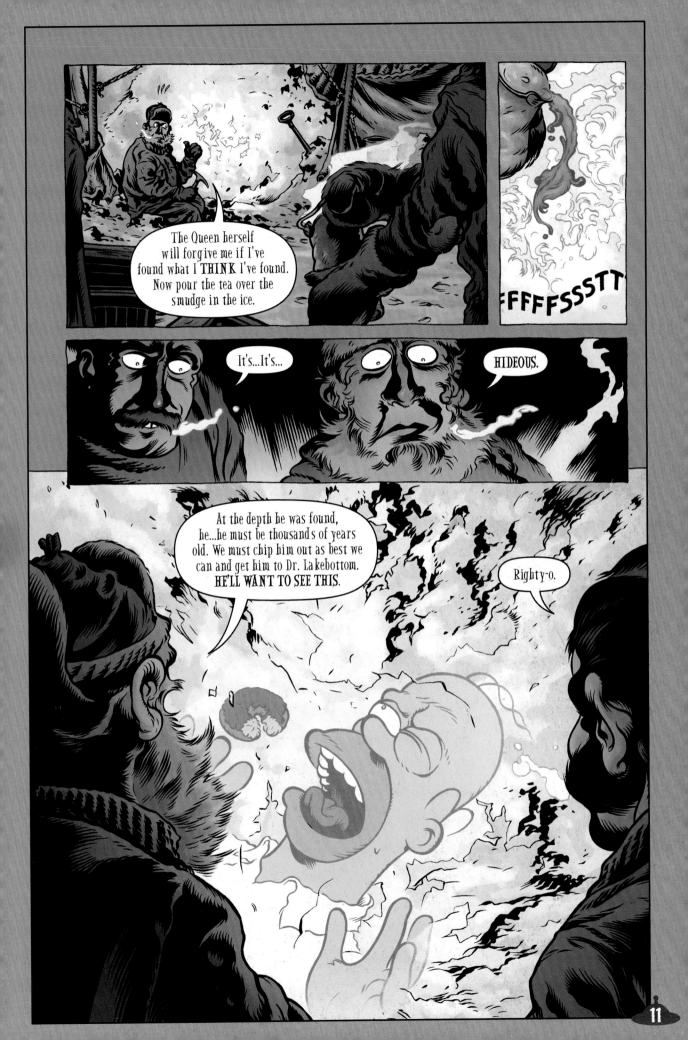

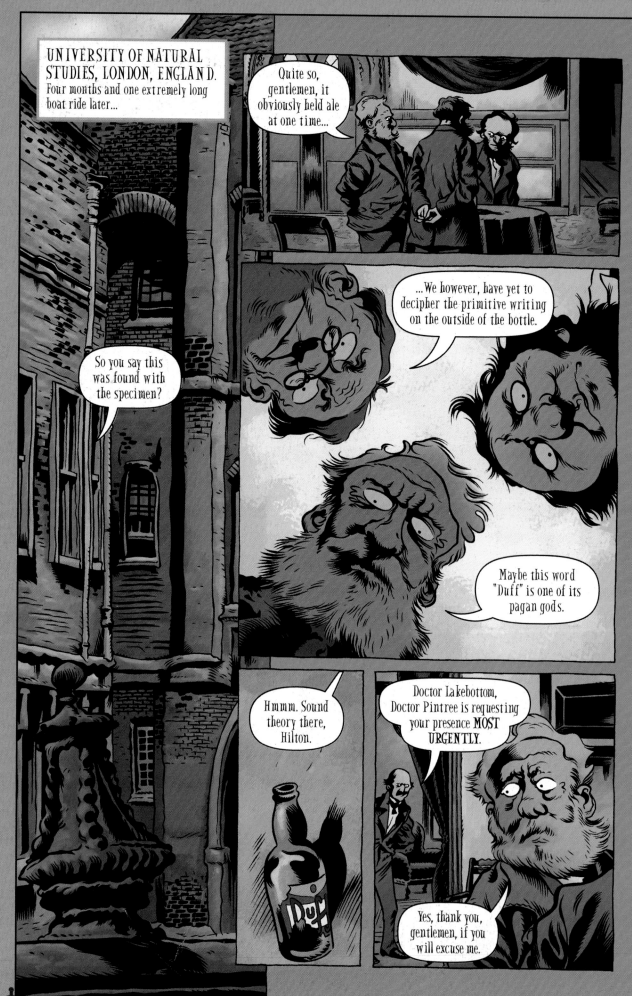

UNIVERSITY OF NATURAL STUDIES, LONDON, ENGLAND. Four months and one extremely long boat ride later...

Quite so, gentlemen, it obviously held ale at one time...

...We however, have yet to decipher the primitive writing on the outside of the bottle.

So you say this was found with the specimen?

Maybe this word "Duff" is one of its pagan gods.

Hmmm. Sound theory there, Hilton.

Doctor Lakebottom, Doctor Pintree is requesting your presence MOST URGENTLY.

Yes, thank you, gentlemen, if you will excuse me.

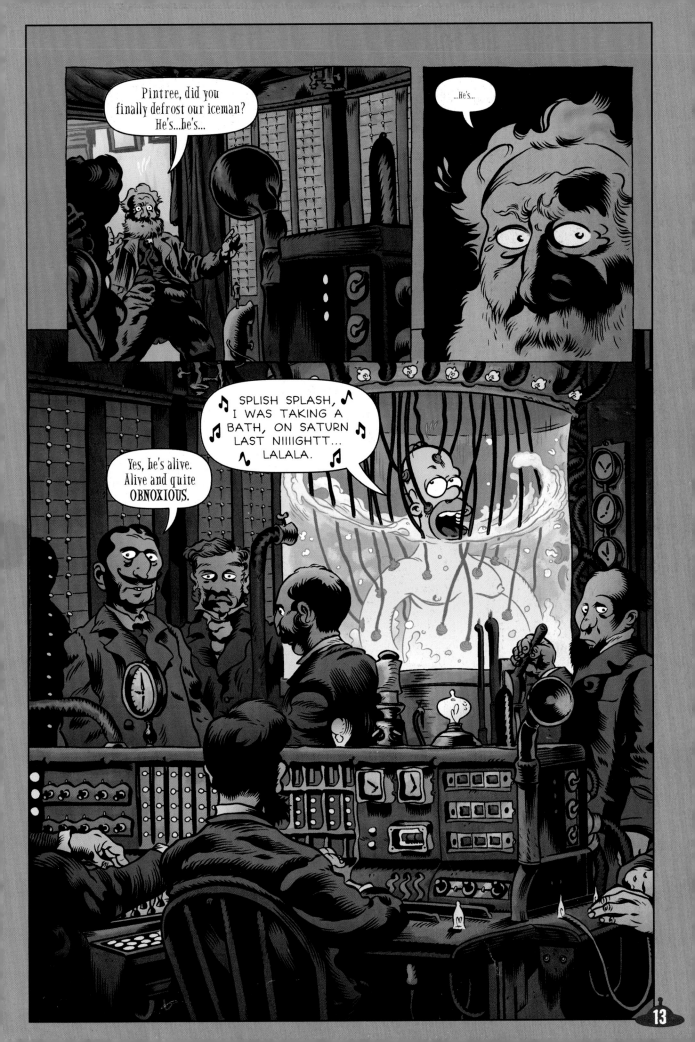

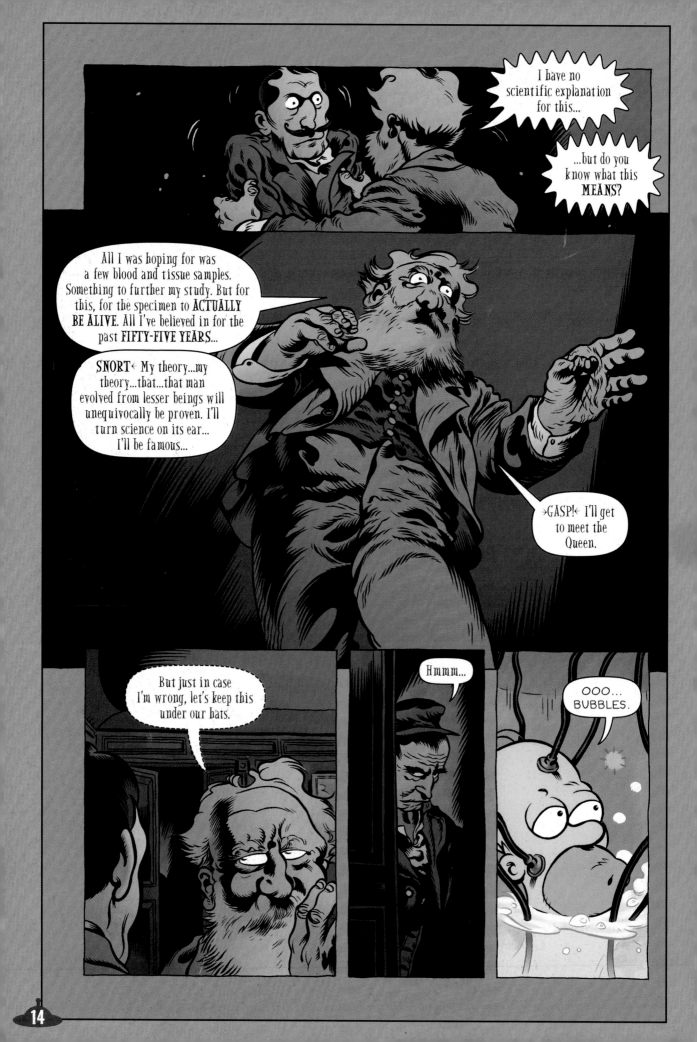

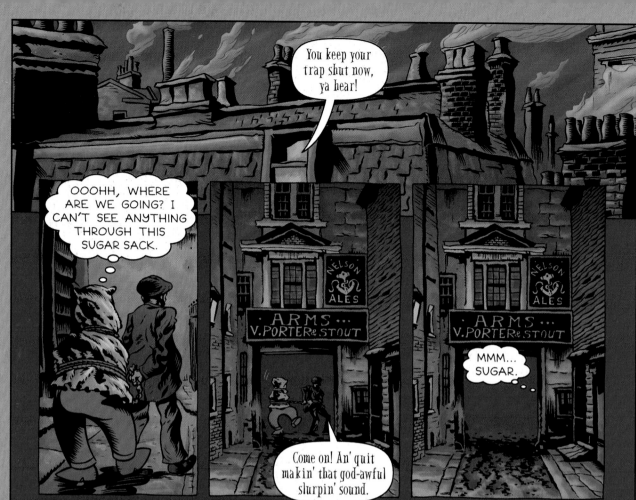

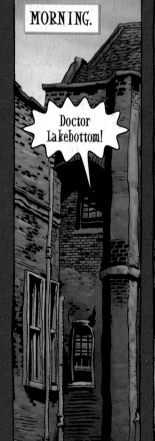

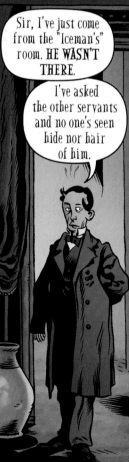

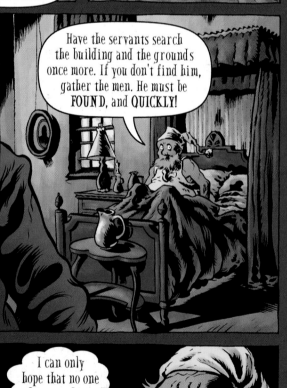

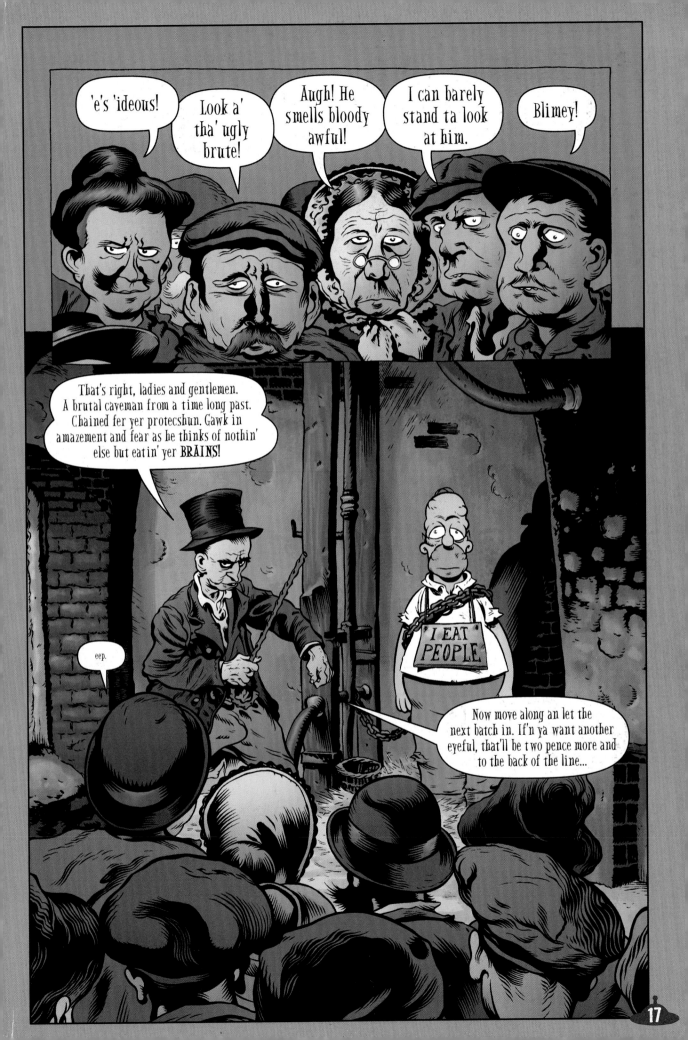

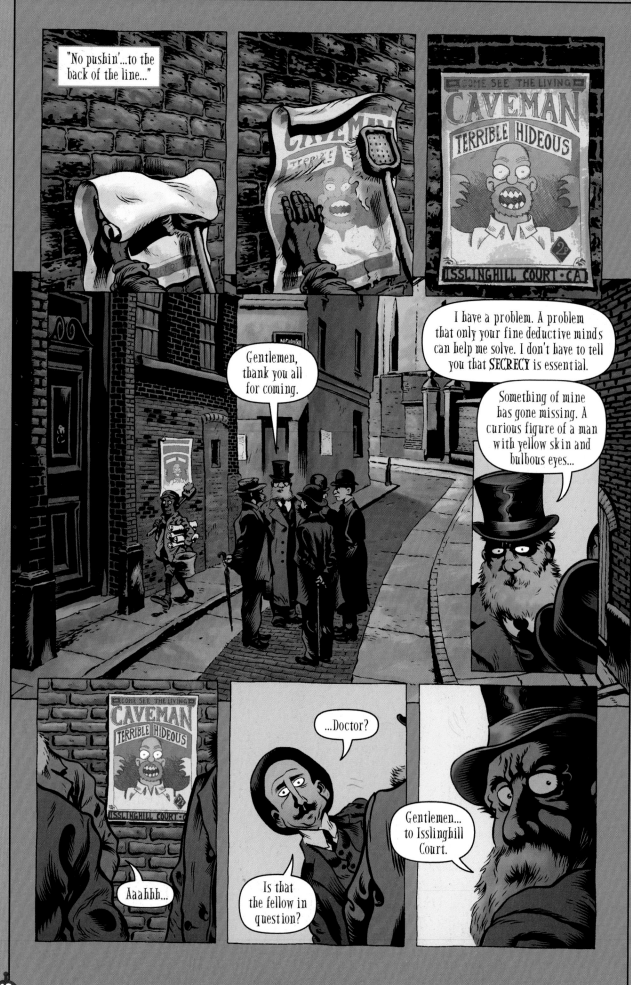

BANG!

BANG!

Get off! If'n ya want ta see the monster, come back tomorrow.

KER-ACK!

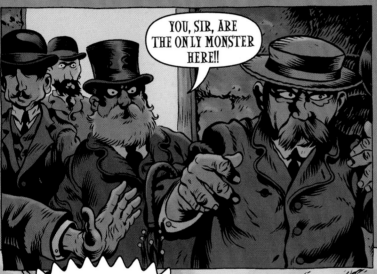

YOU, SIR, ARE THE ONLY MONSTER HERE!!

Gleep.

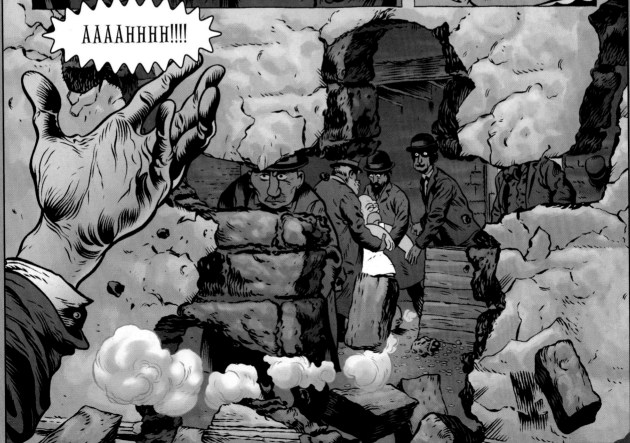

AAAAHHHHH!!!!

How fortunate for the Iceman that he was brought back to the University and, under the careful supervision of Doctor Lakebottom, allowed to heal both his physical and mental injuries.

And when he was well enough, the good doctor put his "find" through a barrage of tests. He was determined to prove his theory that man had indeed evolved from this ugly brute.

PUFF! PUFF!

GLUG! GLUG!

TEE-HEE!

ZZZZZZZTTTTT

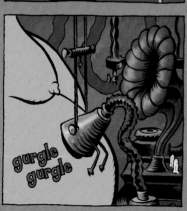

gurgle gurgle

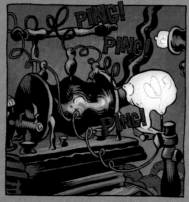

PING! PING! PING!

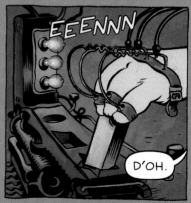

EEENNN

D'OH.

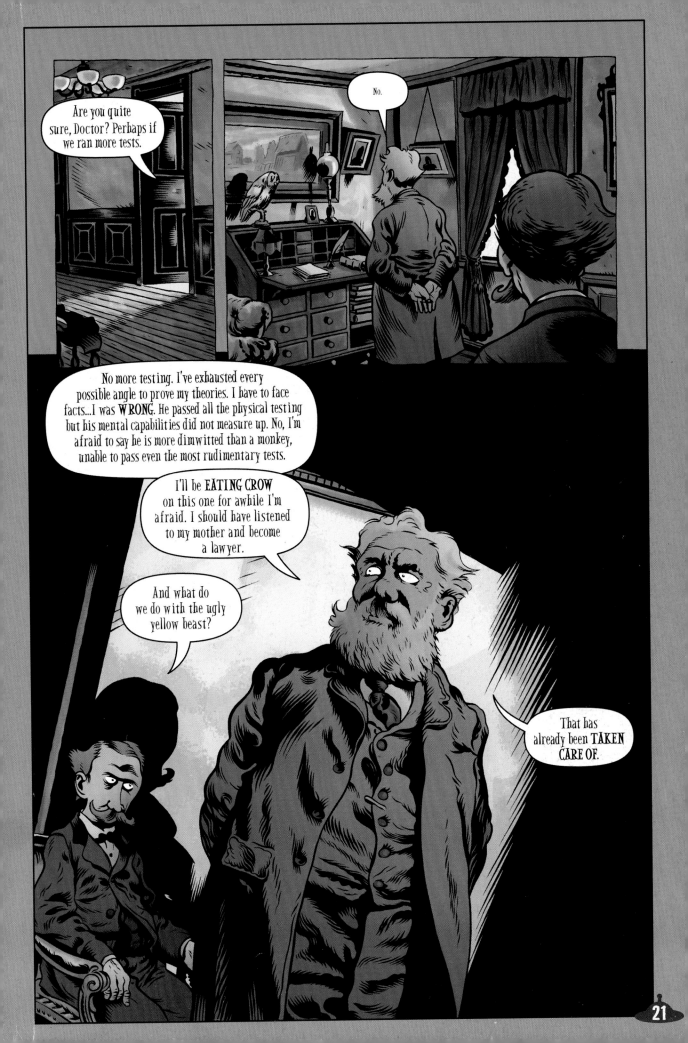

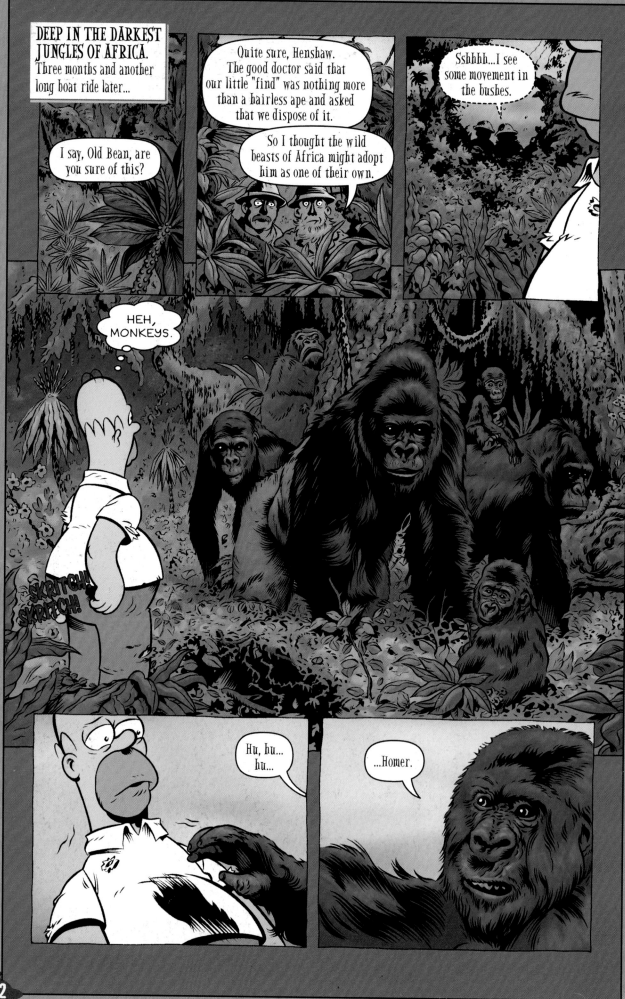

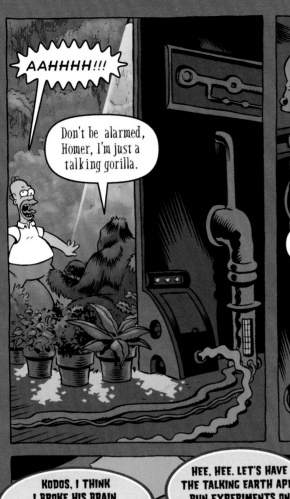

AAHHHH!!!

Don't be alarmed, Homer, I'm just a talking gorilla.

Would you...

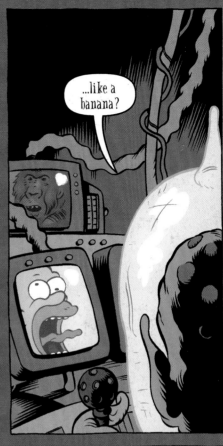

...like a banana?

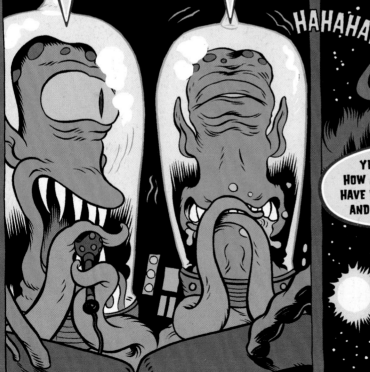

KODOS, I THINK I BROKE HIS BRAIN. ∋HMMPPH∈ WHAT SHOULD WE DO NEXT?

HEE, HEE. LET'S HAVE THE TALKING EARTH APES RUN EXPERIMENTS ON HIM NOW. HAHAHA!!

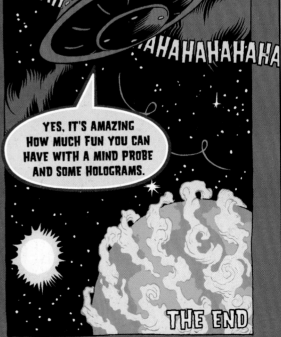

I LOVE MESSING AROUND WITH THESE PUNY EARTH CREATURES.

HAHAHAH

AHAHAHAHAHA

YES, IT'S AMAZING HOW MUCH FUN YOU CAN HAVE WITH A MIND PROBE AND SOME HOLOGRAMS.

THE END

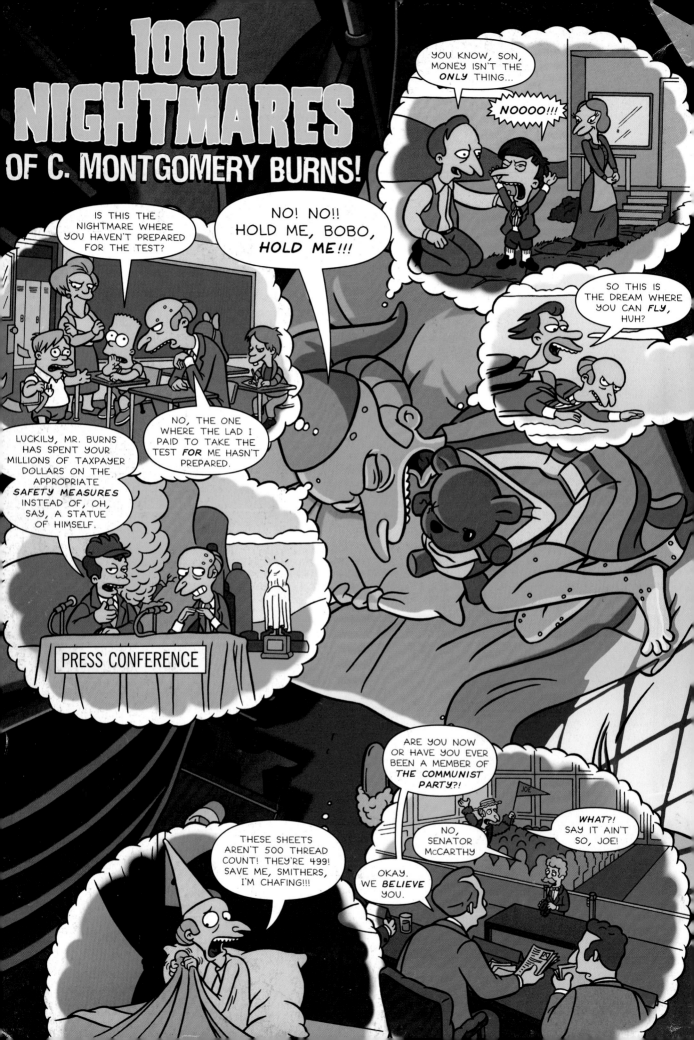

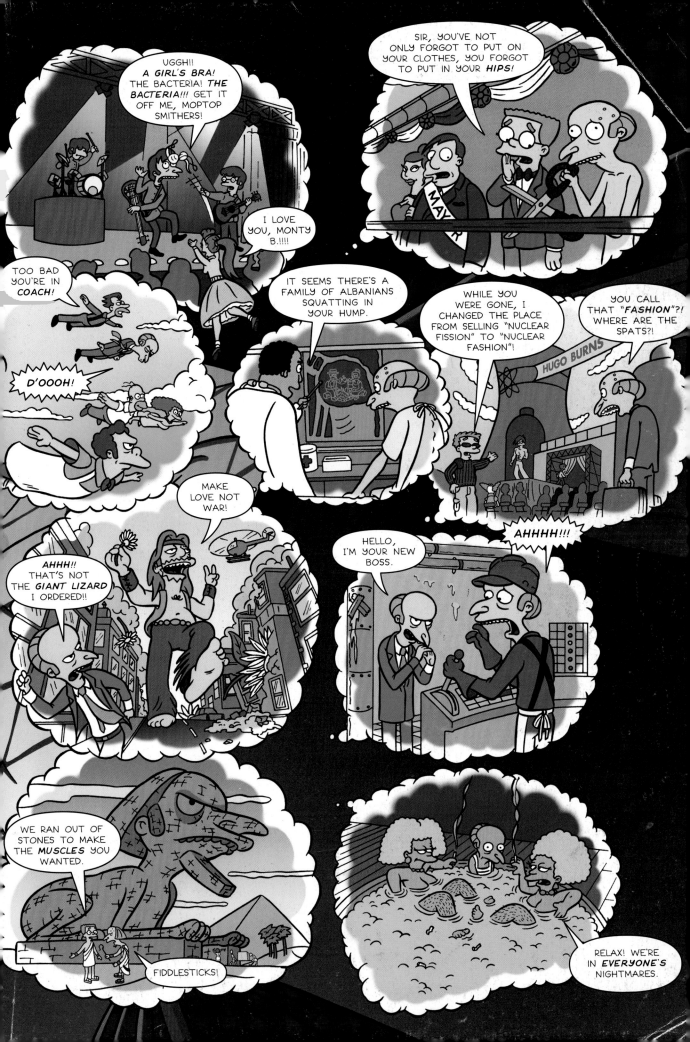

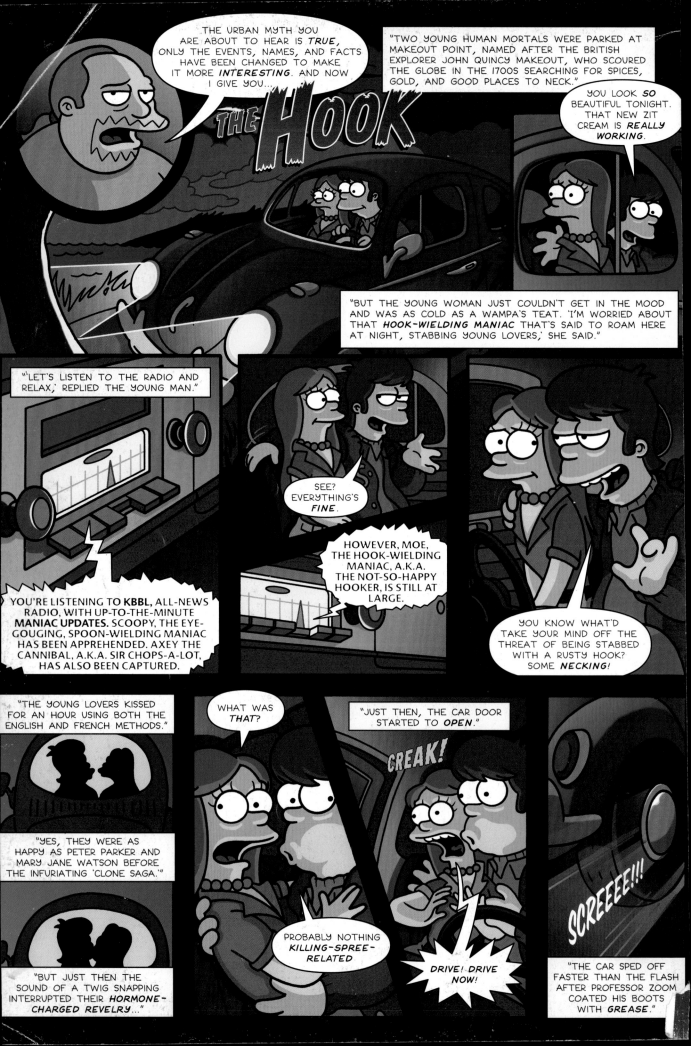

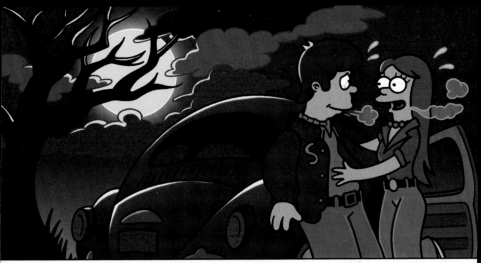

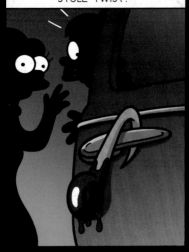

"ABOUT A MILE DOWN THE ROAD, THE COUPLE GOT OUT OF THE CAR TO CATCH THEIR BREATH, MUCH LIKE I HAVE TO DO AFTER WALKING UP THE THREE STAIRS TO MY MOTHER'S FRONT DOOR. I'VE ASKED HER **REPEATEDLY** TO HAVE A RAMP PUT IN, BUT SHE DOESN'T LISTEN! ANYWAY, THEY AGREED THAT IN THE MIDST OF ALL THE SMOOCHING, ONE OF THEM PROBABLY OPENED THE DOOR WITH THEIR ELBOW AND THAT IT HAD ALL BEEN SOME KIND OF **PARANOID DELUSION**."

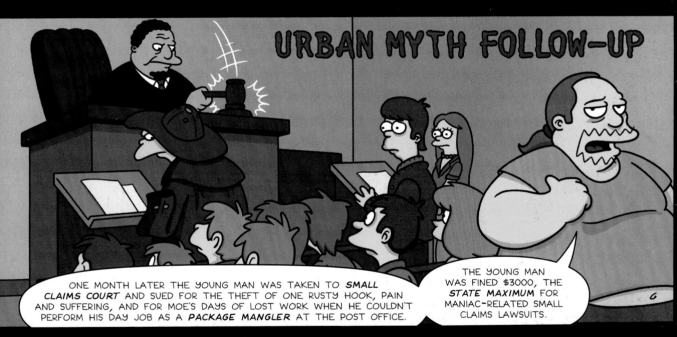

URBAN MYTH FOLLOW-UP

ONE MONTH LATER THE YOUNG MAN WAS TAKEN TO **SMALL CLAIMS COURT** AND SUED FOR THE THEFT OF ONE RUSTY HOOK, PAIN AND SUFFERING, AND FOR MOE'S DAYS OF LOST WORK WHEN HE COULDN'T PERFORM HIS DAY JOB AS A **PACKAGE MANGLER** AT THE POST OFFICE.

THE YOUNG MAN WAS FINED $3000, THE **STATE MAXIMUM** FOR MANIAC-RELATED SMALL CLAIMS LAWSUITS.

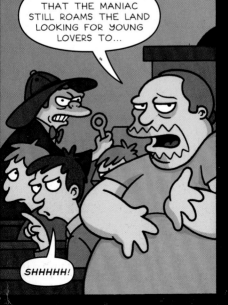

THEY SAY THAT THE MANIAC STILL ROAMS THE LAND LOOKING FOR YOUNG LOVERS TO...

SHHHHH!

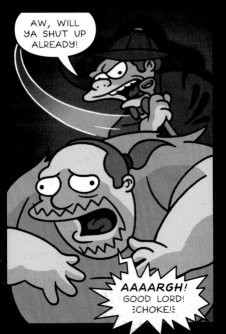

AW, WILL YA SHUT UP ALREADY!

AAAARGH! GOOD LORD! ⸢CHOKE!⸣

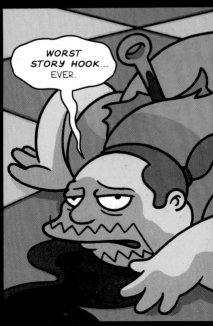

WORST STORY HOOK... EVER.

FINALLY, A TEST I *CAN'T* FAIL. WHY? BECAUSE I *WROTE* IT! *AND* I'M SLEEPING WITH THE TEACHER!

HOMER'S BIG-TIME SMARTYPANTS HALLOWEEN QUIZ

MULTIPLE CHOICE (4 POINTS)

1. WHO INVENTED HALLOWEEN?

A. HAL O. WEINER
B. JESUS, IN HONOR OF HIS BIRTHDAY
C. THAT GUY WHO INVENTED THE RUBIK'S CUBE, YOU KNOW, WHAT'S-HIS-NAME
D. THAT GUY WHO INVENTED THE RUBIK'S CUBE'S DOG

ANSWER: D. I SAY THE DOG DID IT! AND WHY NOT?! DOGS NEVER GET CREDIT FOR ANYTHING! THEY HAVE TO SIT AROUND ALL DAY, DOING WHATEVER THEIR MASTER TELLS THEM. "GET MY SLIPPERS! FETCH ME MY PIPE! MAKE ME A MOCHACCINO! AND WITHOUT SO MUCH FOAM THIS TIME! DID YOU HEAR ME?! LESS FOAM!!"... SO IF YOU ANSWERED "B, JESUS," YOU WERE CORRECT.

2. WHY AM I SO SCARED OF SPIDERS?

A. MULTIPLE EYES, FOUR HAIRY LEGS, FOUR HAIRY ARMS... THEY'RE LIKE PATTY AND SELMA TAPED TOGETHER.
B. THEY CREEP. THEY CRAWL. THEY CREEP AND CRAWL!!!
C. FANGS OR SOMETHING.
D. IF, AND THIS IS A BIG "IF," I WERE TO HAVE A SECRET LOVE OF PLAYING THE FLUTE AND IF A SPIDER WERE TO LAY EGGS IN THAT FLUTE AND IF THOSE BABY SPIDERS WERE TO HATCH AND RUN INTO MY MOUTH WHILE I WAS SECRETLY PLAYING RAVEL'S "BOLERO" AND IF THEIR BITES WERE TO FEEL A LITTLE LIKE THE BURNING SENSATION I GET FROM THE BUBBLES THAT ENGULF MY MOUTH WHILE DRINKING A NICE COLD BUZZ COLA AND IF THEN EVERY TIME YOU DRANK A NICE COLD BUZZ COLA IT REMINDED YOU OF A MOUTHFUL OF SPIDERS, WELL THEN, MR. SMARTYPANTS, I THINK YOU'D BE PRETTY SCARED OF BUZZ COLA, TOO!

ANSWER: DISREGARD ANSWER "D".

3. WHEN WAS THE LAST HALLOWEEN?

A. LAST YEAR, NUMBSKULL!
B. OR WAS IT REALLY STILL THIS YEAR, BECAUSE WE HAVEN'T GOTTEN AROUND TO A NEW YEAR YET? PRETTY CLEVER, EH, EINSTEIN?!
C. CLEVER?! YOU CAN'T EVEN SPELL "CLEVER"!
D. OH, YEAH?! H-O-M-E-R! HA!
E. TOUCHÉ, MY QUICK-WITTED ADVERSARY! AND NOW... TO THE BREWPUB!
F. TO THE BREWPUB!!

ANSWER: THE TWO LATTER-DAY OSCAR WILDES CANTERED OFF TO THEIR LOCAL TAVERN FOR MORE VERBAL JOUSTING AND SCANDALOUS MERRIMENT. THE END.

4. THIS HALLOWEEN, WHICH OF MY FAMILY MEMBERS SHALL BETRAY ME?

A. BART C. MAGGIE
B. MARGE D. LISA

ANSWER: E. TO BE SAFE, I SHALL HAVE THEM ALL DONE AWAY WITH.

COMPARISONS (4 POINTS)

THIS PART'S PRETTY TOUGH, SO STICK WITH ME. A COMPARISON IS SOMETHING LIKE: "MITTENS" ARE TO "HANDS," AS "PANTS" ARE TO "LEGS." GET IT? MITTENS "COVER" YOUR HANDS AND PANTS "COVER" YOUR LEGS (AT LEAST THEY DO NOW, THANKS TO A LITTLE INVENTION CALLED "STRETCH DENIM"!)

1. "HALLOWEEN" IS TO "STUFFING MYSELF WITH CANDY" AS "THANKSGIVING" IS TO...
2. "ALL HALLOW'S EVE" IS TO "EVERYONE LOVES MY DEVIL COSTUME" AS "CHRISTMAS EVE" IS TO...
3. "HOMERWEEN" IS TO "A DAY I MADE UP TO TRY AND GET MORE FREE CANDY FROM THE NEIGHBORS" AS "POLICE INVESTIGATION OF HOLIDAY FRAUD" IS TO...
4. "A BLACK CAT CROSSING YOUR PATH" IS TO "BAD LUCK" AS "HOLDING A BLACK CAT WHILE WALKING UNDER A LADDER AND BREAKING A MIRROR" IS TO...

1. "STUFFING THE TURKEY WITH CANDY (AND THEN STUFFING MYSELF WITH CANDIFIED TURKEY.)"
2. "WELL, THAT'S ONE MORE CHURCH I'M KICKED OUT OF.
3. "SOMETHING YOU DON'T NEED TO WORRY YOUR BUSY NOSE ABOUT, NOW, GIMME MY HOMERWEEN CANDY!"
4. "THE STORY OF MY LIFE."

WORD FIND (12 POINTS) (THIS SECTION IS WHAT KEPT ME OUT OF HARVARD) GOOD LUCK FINDING THE MOST TERROR-TASTICAL FRIGHT WORDS IN MY SPOOKTIONARY!

GASP	EEK	DEVIL MOUSE
VAMPIRE	TOILET CLOG	MR. BURNS
ARRGH	THIMBLE	BUTTERY DEATH
AUDIT	FAT FREE	THE BOY

BARNEY'S TAVERN-ORIENTED STORY PROBLEM (1 POINT)

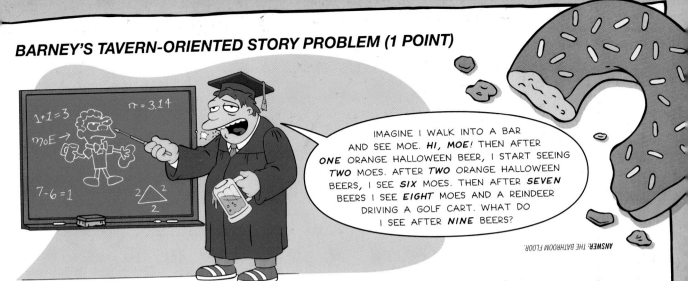

IMAGINE I WALK INTO A BAR AND SEE MOE. *HI, MOE!* THEN AFTER *ONE* ORANGE HALLOWEEN BEER, I START SEEING *TWO* MOES. AFTER *TWO* ORANGE HALLOWEEN BEERS, I SEE *SIX* MOES. THEN AFTER *SEVEN* BEERS I SEE *EIGHT* MOES AND A REINDEER DRIVING A GOLF CART. WHAT DO I SEE AFTER *NINE* BEERS?

ANSWER: THE BATHROOM FLOOR.

CONNECT THE DOTS TO DISCOVER MY GREATEST HALLOWEEN FEAR!!! (1 POINT)

MUST CUT IN HALF!!

NOOOO!!!

ESSAY (8 POINTS)

USING THE SHAKESPEAREAN SONNET FORM, DESCRIBE YOUR FAVORITE HALLOWEEN CANDY.

HOMER

POPCORN balls

POOL

ODE TO A POPCORN BALL
BY HOMER J.!

SHALL I COMPARE THEE TO A POPCORN BALL?
THOU HAST LESS CRUNCHINESS AND CARAMEL.
THE FATTY GOODNESS MAKES ME RUN NOT CRAWL
TO WALLOW NAKED IN ITS SACRED SMELL!
OUCH! ITS CORNY SURFACE IS BOTH ROUGH AND CRUEL
UPON MY OH SO SENSITIVISH SKIN.
YET ITS HEAVENLY GREASE STILL MAKES ME DROOL.
 A POOL OF POPCORN BALLS? I'LL JUMP RIGHT IN!
I DO A NAKED POPCORN CANNON BALL
AND A JACKKNIFE DIVE WITH MY RUMP TO KNEE,
 BUT THE SECURITY CAM HAS CAUGHT IT ALL
 AND I'M FIRED FROM THE POPCORN COMPANY!
 MY LOVE OF POPCORN BALLS HAS GOT ME TOSS'D.
 I'LL GO HOME AND FLOSS PLACES I'VE NEV'R FLOSS'D.

HOW DID YOU SCORE?

1-8 WEAK. DID YOU ERASE MY ESSAY?! THAT WAS EIGHT FREE POINTS I GAVE YOU!

9-10 MEEK. A LITTLE SPOOKIER, BUT I'D STILL LET YOU BABYSIT MY KIDS.

11-20 CREAK! I'VE SEEN YOU SOMEWHERE BEFORE... WAIT A MINUTE, WEREN'T YOU ON THE LOCAL NEWS?!

21-25 EEK! MARGE! LOCK THE DOOR! THEN PUT THE COUCH IN FRONT OF IT! THEN PUT THE CHILDREN IN FRONT OF THE COUCH!

26-30 YOU'RE A UNIQUE SHRIEK FREAK! AAAAAAAAAAAAGGHH!! IT'S GOT ME!!!! WHERE'S MY GOD TO RESCUE ME IN HIS MAGIC SLEIGH?!!!!!

THEN SCRAMBLE, DON'T RAMBLE TO BUY:

FREEZE-DRIED FOR SALE ON MEN WILL BE MARS, ♂ WOMEN WILL BE FREEZE-DRIED FOR SALE ON VENUS

Male and female humans are the same. Right? WRONG!!! Even their genetic code is different! How different? Try .00000003% different! It is why men cannot fold laundry... and more!

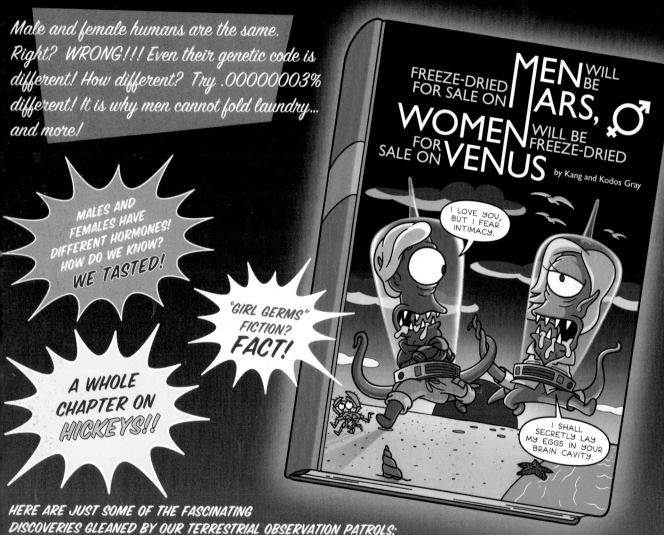

MALES AND FEMALES HAVE DIFFERENT HORMONES! HOW DO WE KNOW? WE TASTED!

"GIRL GERMS" FICTION? FACT!

A WHOLE CHAPTER ON HICKEYS!!

FREEZE-DRIED FOR SALE ON MEN WILL BE MARS, ♂ WOMEN WILL BE FREEZE-DRIED FOR SALE ON VENUS
by Kang and Kodos Gray

I LOVE YOU, BUT I FEAR INTIMACY.

I SHALL SECRETLY LAY MY EGGS IN YOUR BRAIN CAVITY.

HERE ARE JUST SOME OF THE FASCINATING DISCOVERIES GLEANED BY OUR TERRESTRIAL OBSERVATION PATROLS:

THE MALE OF THE SPECIES	THE FEMALE OF THE SPECIES
• Endeavors to maintain possession of the televisual remote control device.	• Endeavors to outlive the male in order to regain control of said device.
• Insists the lid to the excretion receptacle remain in the "up" position, perhaps to aid in removal of unwanted pets.	• Insists lid be in "down" or "safety" position to prevent surprise attack from previously disposed of pets.
• Incapable of obtaining directions to destinations while operating terrestrial transportation vehicle.	• Incapable of obtaining directions to brain-immobilization gun in order to commandeer said vehicle.
• Wears a mustache to conceal lip and pants to conceal appendages, except in the land known as Scotland where a "skirt" is worn.	• Wears a skirt to conceal appendages and "lipstick" to conceal lip, except in Scotland where a mustache is worn.

Finally, you too will understand why your counterparts say different things, do different things, and why their stringy meat should be digested by a creature from a different planet! Vive la différence!

FroM DUFFs TiLL DaWN

So, you've come for a tale on this All Hallow's Eve that'll fill you all up full of dread?

Well, beware, lads and lassies, you'll fear to believe what I say, 'cause you'll wish you were dead.

Scott "No Remorse" Morse
Writer/Artist

Carrion Bates
Letters

Petey "The Magic Monkey" Dog
Page Destroyer

Mortifyin' Bill Morrison
Editor

Malodorous Matt Groening
Barkeep

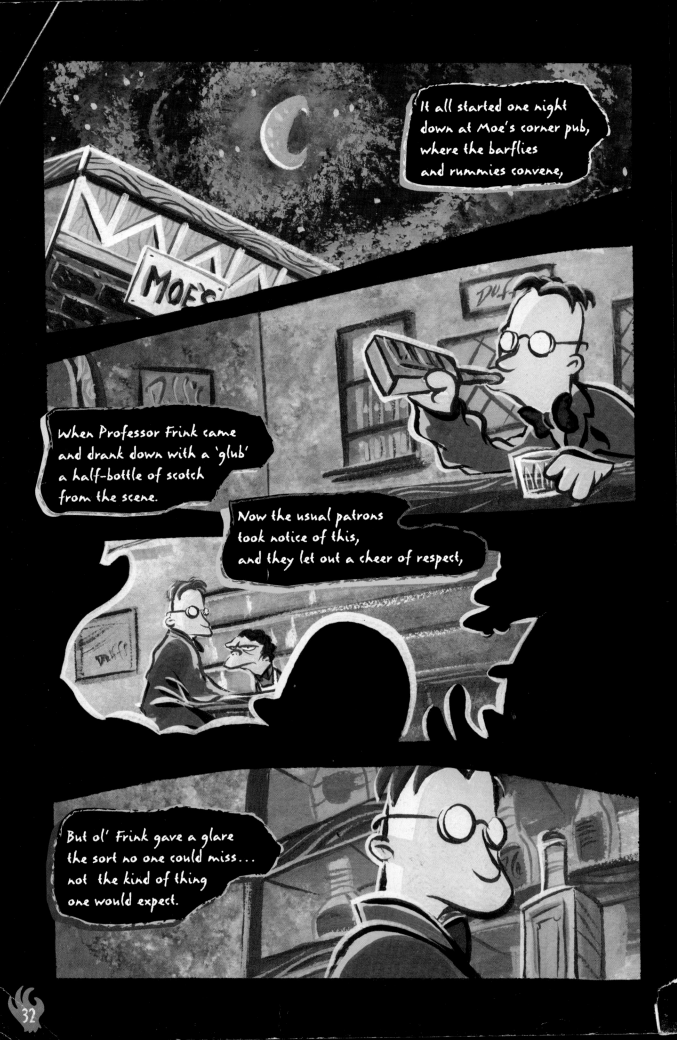

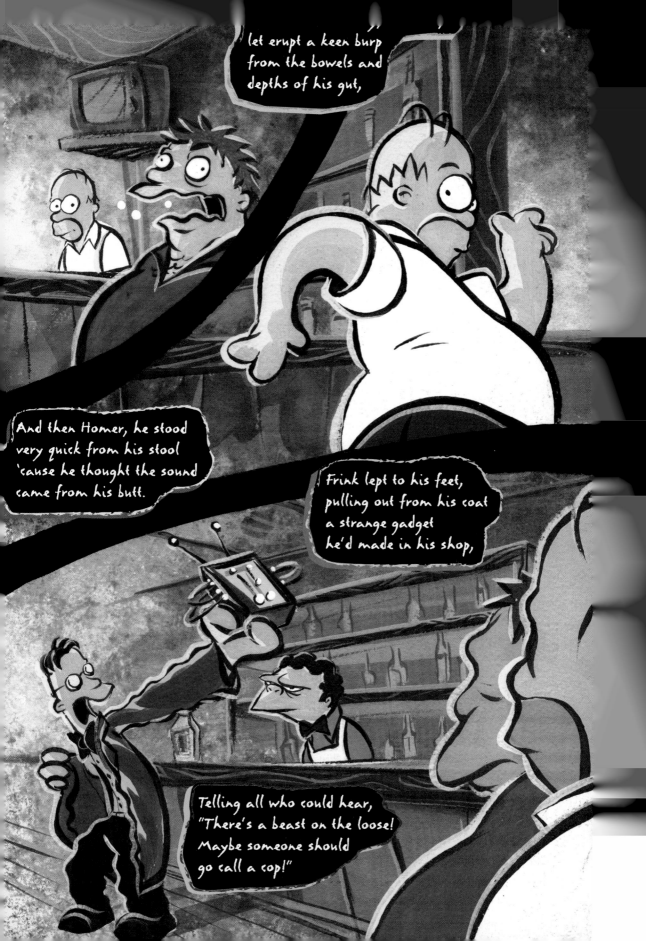

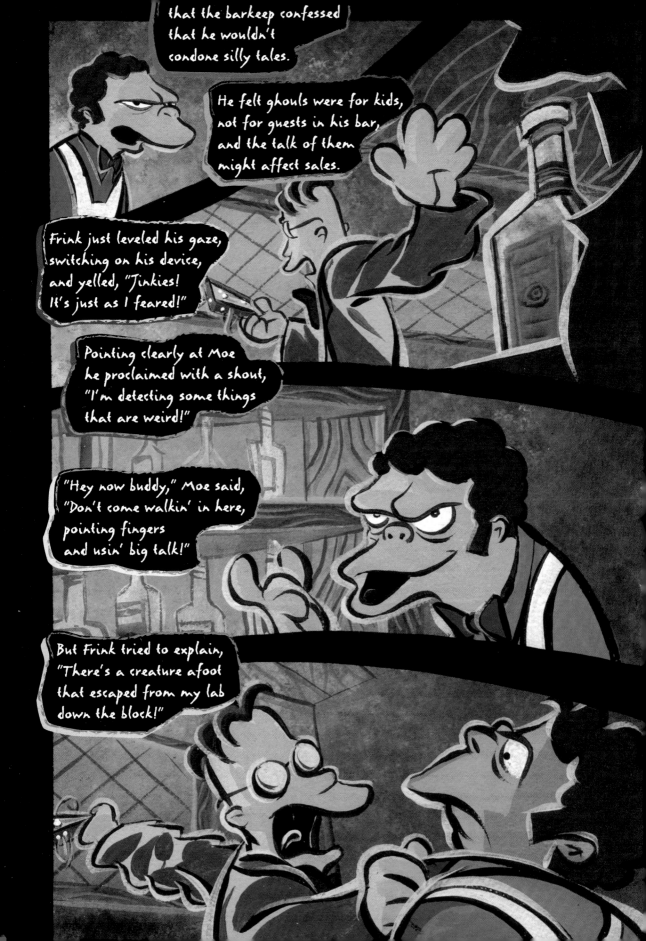

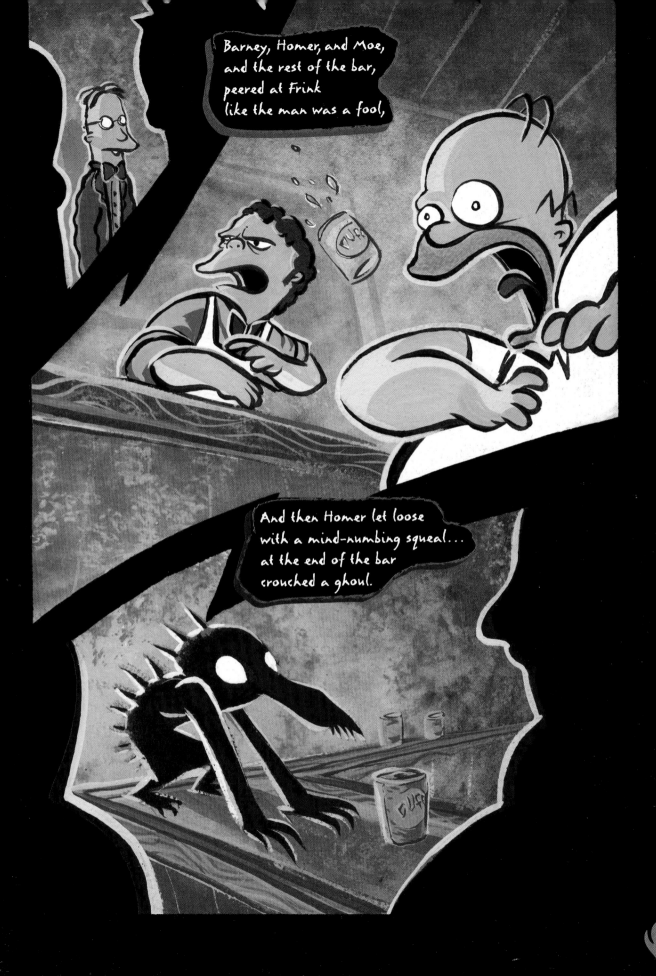

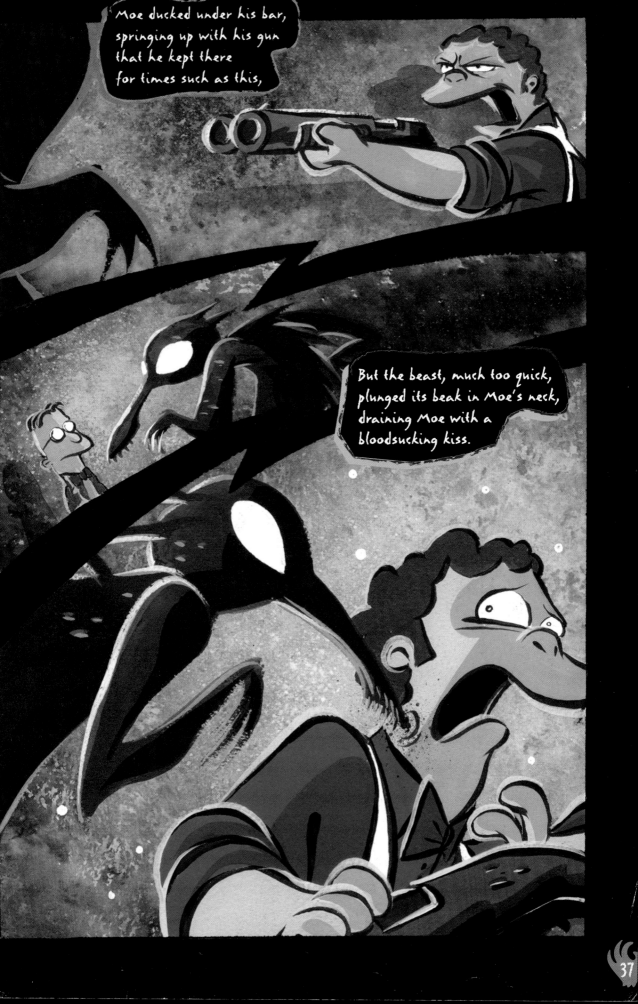

Moe ducked under his bar, springing up with his gun that he kept there for times such as this,

But the beast, much too quick, plunged its beak in Moe's neck, draining Moe with a bloodsucking kiss.

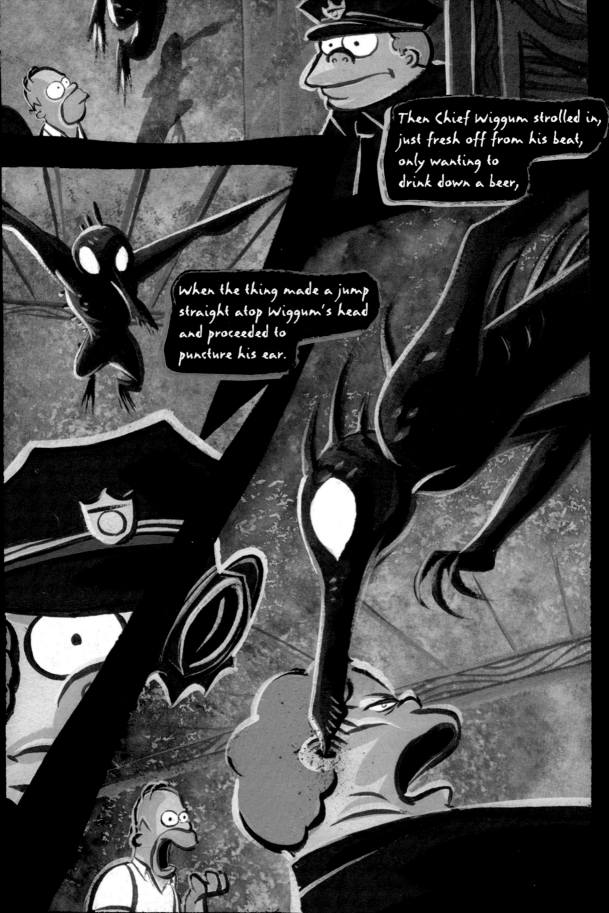

Old man Jasper was next,
with a poke through his neck,
followed soon by
the Bumblebee Guy,

Then the Sea Captain dropped
with a death-rattle, "Arrghhh..."
There were few people
left there to die.

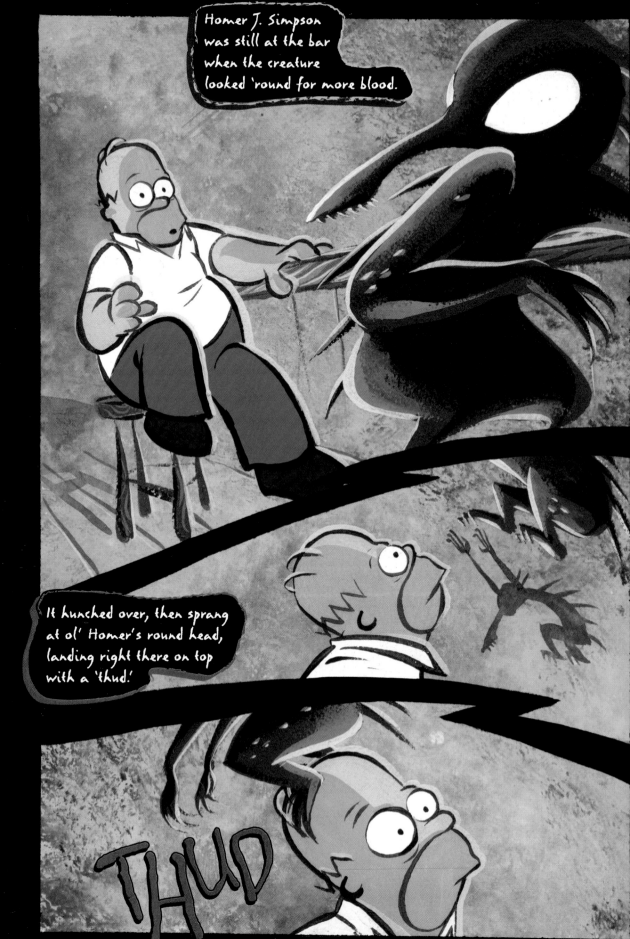

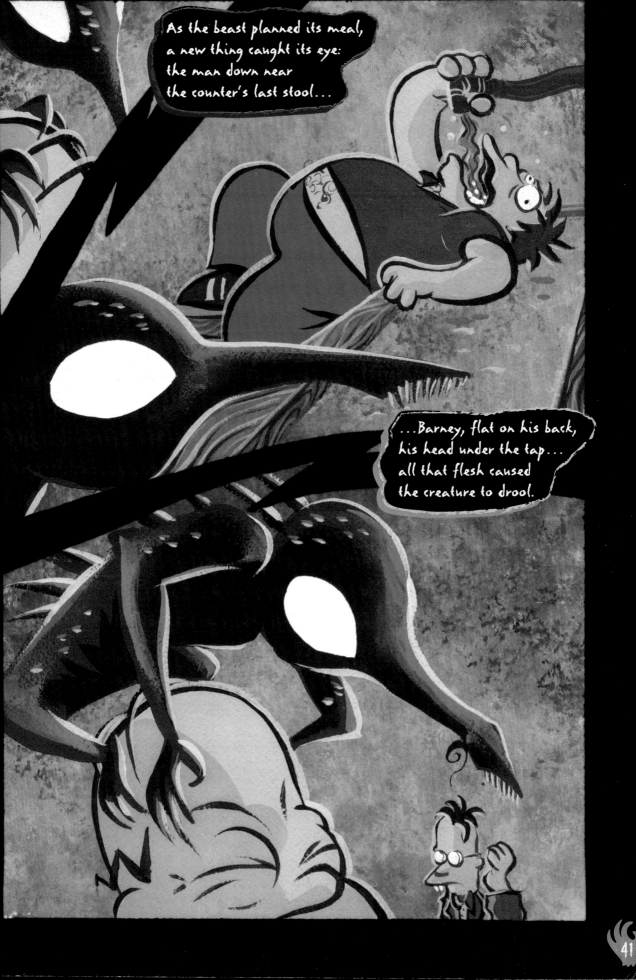

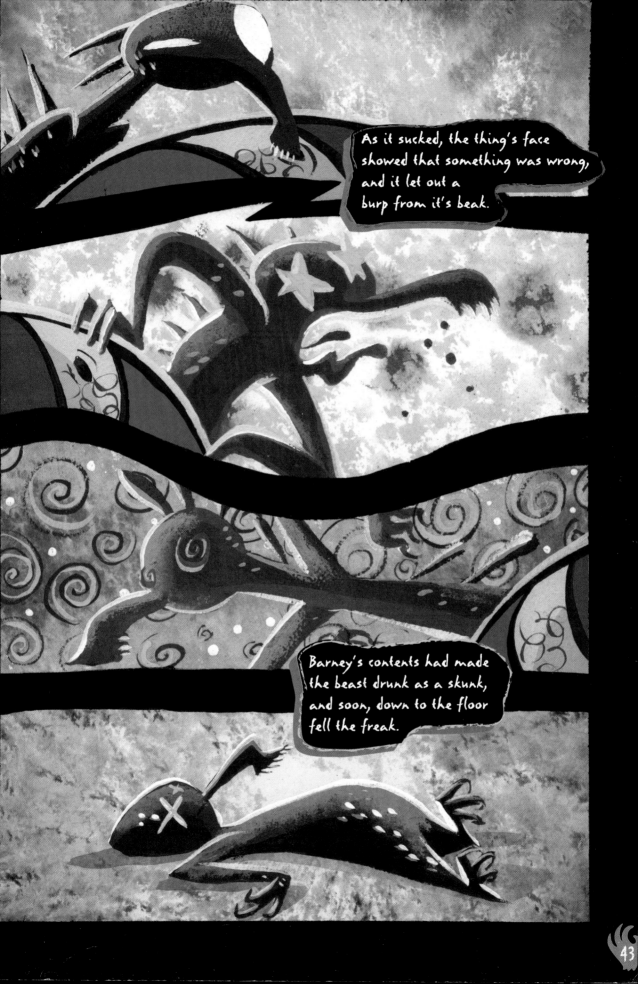

"Chupacabras," said Frink, "was what we called the beast, since it likes to drink blood from a goat.

"If there's one thing we've grown in the lab that I fear, I assure you this thing gets my vote.

"So, my friend, thank your stars that this drunkard was here, or the beast wouldn't be where it lay."

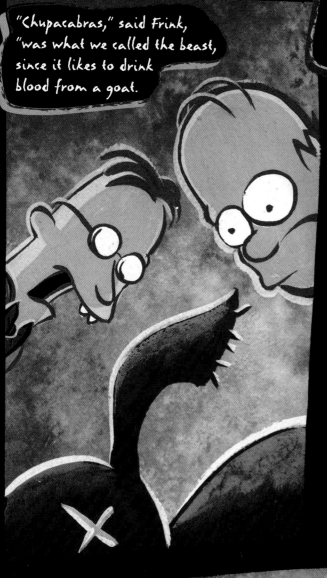

Homer smiled, content that his life had been spared because once again, beer saved the day.

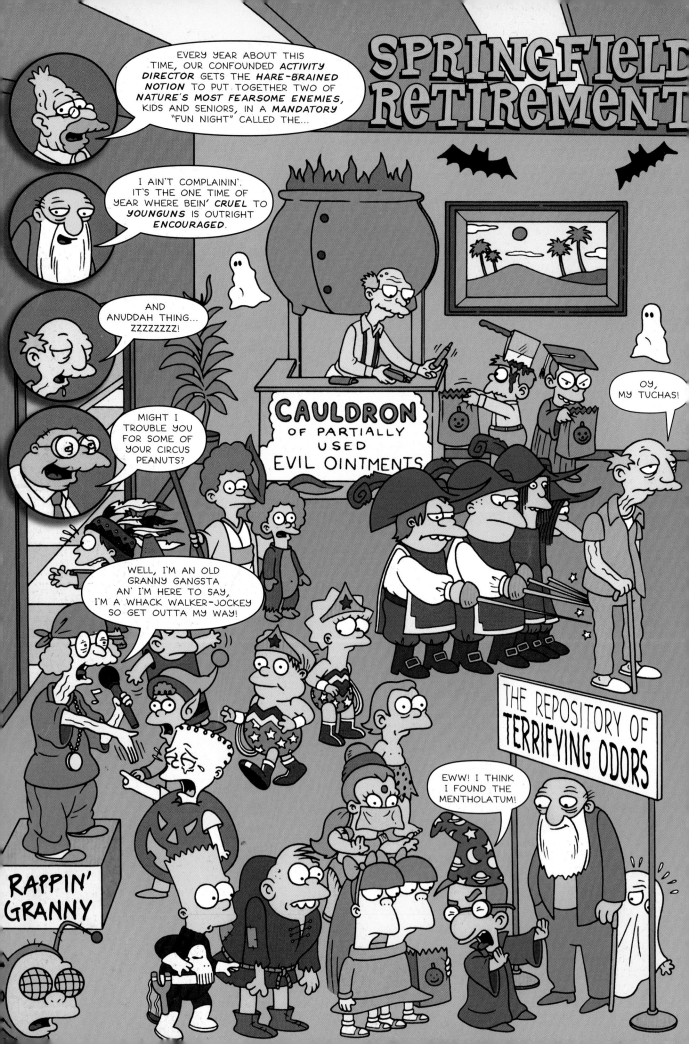

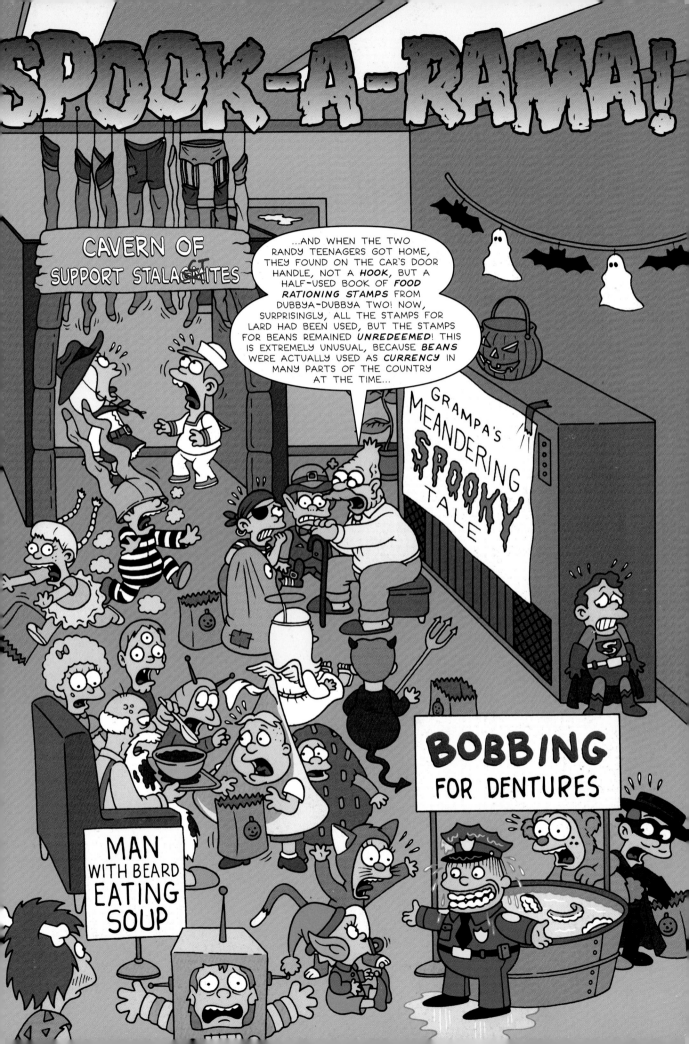

THE STORY I'M ABOUT TO TELL YOU CLOWNS *REALLY* HAPPENED TO ME. SWEAR TO GOD! IF IT AIN'T *FIVE HUNDRED PERCENT TRUE*, MAY A HOBO FRY MY BRAINS FOR AN OMELET!

MOE'S URBAN TALES OF TERROR!!!
#62: THE PHANTOM GIRLFRIEND!!

THE YEAR WAS 1977...OR '79...(LOOK, IT WAS THE SEVENTIES, EVEN THE GOVERNMENT DIDN'T KNOW WHAT YEAR IT WAS!) I HAD JUST FINISHED BARTENDER ACADEMY AT THE VERY TOP A MY CLASS...AT LEAST I WOULDA IF KENNY ERB HADN'T SWIPED MY RECIPE FOR THE BATTLESTAR GIN-LACTICA...(SIGH) THE DRINK THAT GOT AWAY. WHATEVER! WITH A PH.D. IN BOOZEOLOGY, I COULD WRITE MY TICKET TO POUR AT ANY A THE HOTSPOTS: STUDIO 54, THE POLO LOUNGE, LIZA MINELLI...BUT A LITTLE BUG INSIDE ME SAID, "NO, MOESY! STRIKE OUT ON YOUR OWN!" SO I MOVED TO SPRINGFIELD AND BEGAN BUILDING THE PERFECT CLUB. OR WAS IT?! FOR WHAT I DIDN'T KNOW WAS I HAD BUILT MY "PERFECT CLUB" RIGHT ON THE SITE OF AN ANCIENT INDIAN BURIAL MOUND!!!!! (AND CASINO).

OH, THINGS LOOKED GOOD AT FIRST. OPENING NIGHT WAS A HUGE SUCCESS AND SOON EVERY SEQUIN-JOCKEY IN THE STATE WAS BEGGING TO GET INTO A HOT LITTLE CLUB CALLED "E-MOE-TIONS." I KNOW WHAT YOU'RE THINKIN', "OWNER A THE TOWN'S HOTTEST CLUB MUST BE GETTING SOME DISCO DOLL ACTION!" HEH-HEH, WELL...NO. HEY, I KNOW I DON'T LOOK LIKE NO BURT REYNOLDS AND I HAVE CERTAIN SMELLS THAT REACT UNFAVORABLY WITH MOST OVER-THE-COUNTER DEODORANTS, SO LET'S JUST SAY I'M CHOOSY. BUT ONE NIGHT, AFTER THE CLUB HAD CLOSED AND I'D TUCKED THE LAST RUMMY INTO HIS GUTTER BED, I HEARD AN EERIE SOUND. FIRST, I FIGURED IT WAS JUST BARNEY GUMBLE TRYING TO SUCK BEER OFF THE PHONOGRAPH NEEDLE AGAIN. BUT BARNEY WEREN'T THERE. INSTEAD, I SEEN THIS APPARITION OF A BEAUTIFUL INDIAN MAIDEN. AND I MEAN SHE WAS HOT! ALL CURVES AND LEGS...LIKE YA DUCT TAPED CHARO'S BODY ONTO MICHELLE PFEIFFER'S HEAD, BUT WITHOUT THE GOOGLE EYES!

ND YA KNOW WHAT SHE SAYS TO ME? "MOE, YOU HAVE
ISTURBED MY ETERNAL SLUMBER. BUT IT'S OKAY, CUZ...YOU
OT A CUTE LITTLE BUTT!" SWEAR TO GOD! IF I'M MAKIN'
HIS UP, MAY HIPPIES USE MY MOUTH FOR AN ASHTRAY!

O, NEXT NIGHT, I TOLD EVERYONE THEY HADDA GO HOME
ARLY, CUZ I HAD A DATE WITH AN INDIAN MAIDEN. AND A
COURSE, NO ONE BELIEVED ME, CUZ THEY'RE NO-GOOD
UMMIES. BUT I'LL SHOW THEM, RIGHT? SO I HUNG
ROUND IN MY TIGHTEST SLACKS AND SURE ENOUGH, AT
IIDNIGHT, THE MAIDEN CAME BACK. SHE FLOATED OVER
O ME AND PLANTED ONE RIGHT ON THE OL' FISH LIPS.
WHAT A KISS! IT FELT LIKE SOMEONE FIRED A BULLET
OWN MY THROAT. AND I SHOULD KNOW!* BUT
BEFORE SHE COULD
LEAVE AGAIN, I TOLD
HER "THERE'S SOMETHING I DO AT THE END OF
EVERY DATE: TAKE A PICTURE, YOU KNOW, FOR PROOF."

NEXT DAY, I TOLD THE RUMMIES, "YOU DON'T BELIEVE I'M WITH A HOT INDIAN
MAIDEN?" AND I SHOWED 'EM THE PICTURE. BUT IT'S JUST ME WITH MY ARM
AROUND A BUNCHA AIR! CUZ GHOSTS DON'T SHOW UP ON FILM! AND THE
RUMMIES LAUGHED AND MADE JOKES ABOUT "MOE'S GHOUL FRIEND" AND OTHER
THINGS THAT ARE REALLY CLEVER BUT HURT. SO I TOLD THEM TOMORROW I'LL
BRING HER TO THE CLUB FOR EVERYONE TO SEE!

WELL, SHE COULDN'T MAKE IT THAT NIGHT, SO I LOOKED PRETTY BAD...THEN
SHE COULDN'T MAKE IT ANY NIGHT THAT WEEK, SO, YOU KNOW, I FELT
PRETTY DUMB...BUT ON SATURDAY SHE SHOWED UP, RIGHT THERE IN THE
MEN'S ROOM! SO I RAN OUT ON THE DANCE FLOOR AND ANNOUNCED THAT
THE NEXT THING OUT OF THE MEN'S ROOM WILL BE THE HOTTEST GIRLFRIEND
THEY EVER SEEN! BUT JUST AS I OPENED THE DOOR, SHE TURNED INTO A GIANT
FIRE-BREATHING BUFFALO MONSTER AND TORE AROUND THE ROOM EATIN'
PEOPLE! BY THE TIME SHE WAS GONE, FOUR A MY BEST RUMMIES WERE DEAD,
AND MY CLUB WAS IN RUINS. AND YOU KNOW WHAT THE HEADLINE WAS THE
NEXT DAY? "BAR MAN INVENTS GIRLFRIEND!" SWEAR TA GOD! IF I AIN'T TELLIN'
THE TRUTH, MAY ZOOKEEPERS MAKE ME EAT A PLATE A MONKEY BUSINESS!

* SEE "MOE'S URBAN TALES OF TERROR #34: THE TIME THAT GUY FIRED A BULLET DOWN MY THROAT."

HALLOWEEN COPPERS
SPRINGFIELD*

*NOT AFFILIATED WITH "COPS," "STORIES OF THE HIGHWAY PATROL," OR "AMERICA'S FUNNIEST USE OF EXCESSIVE FORCE"

OH, YEAH, HALLOWEEN'S JUST ANOTHER NIGHT ON THE BEAT FOR SPRINGFIELD'S *TOP COP*.

THAT'S ME, BY THE WAY. WHEN I SAID THAT "TOP COP" THING, I WAS REFERRING TO MYSEL...

8:12 EVENING PATROL

REC

CHIEF! WATCH WHERE YOU'RE *DRIVING*!

REC

REC

10 SECONDS LATER, NEXT TO A DRAINAGE DITCH

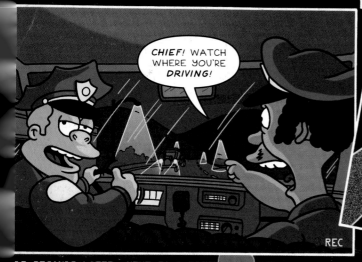

HEY! A FAMILY CAR THAT ALSO WORKS AS A HEARSE! BOY, THAT'S LUXURY *AND* CONVENIENCE!

TAKE 'EM DOWNTOWN, BOYS.

BUT YOU KNOW, IT'S NOT ALL TASERS AND CHOKE HOLDS...NOT BY A *LONG* SHOT! BEING A COP IS ALSO ABOUT INTERACTING WITH THE *PEOPLE*.

LIKE, YOU KNOW HOW ON CHRISTMAS, SOME COPS HAVE A "TOYS FOR TOTS" PROGRAM?

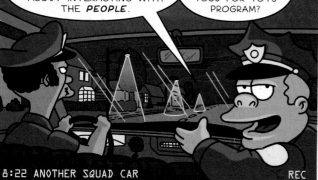

8:22 ANOTHER SQUAD CAR

REC

SEE, FOR HALLOWEEN, I SPEARHEADED A "CANDY FOR COPS" INITIATIVE. THE KIDS REALLY SEEM TO ENJOY IT.

HELP! HE'S TAKING MY BIT O' HONEY *AND* MY DIGNITY!

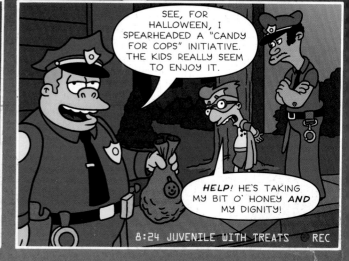

8:24 JUVENILE WITH TREATS

REC

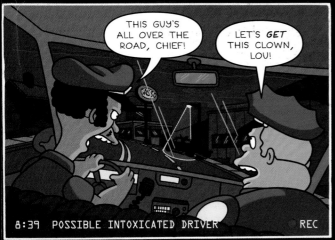

8:39 POSSIBLE INTOXICATED DRIVER ● REC

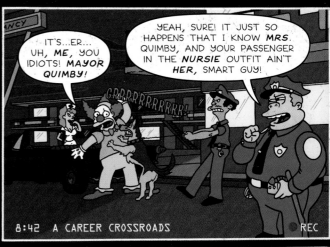

8:42 A CAREER CROSSROADS ● REC

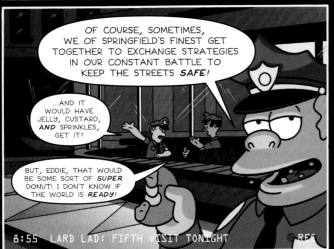

8:55 LARD LAD: FIFTH VISIT TONIGHT ● REC

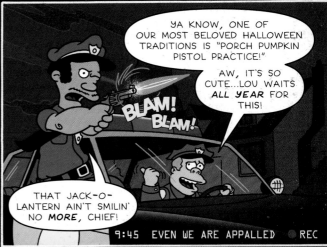

9:45 EVEN WE ARE APPALLED ● REC

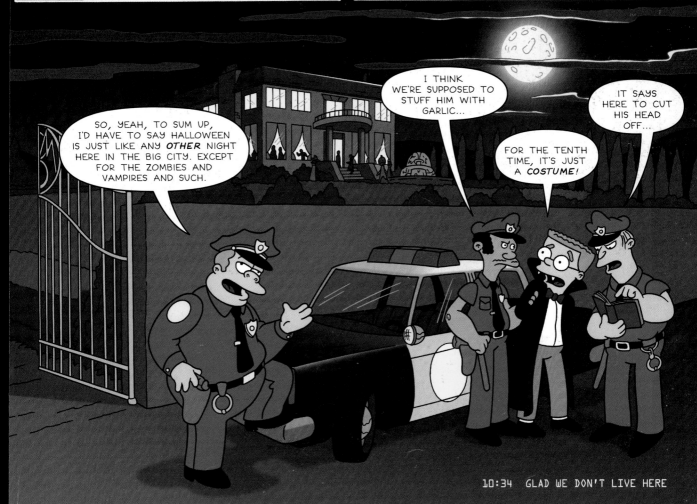

10:34 GLAD WE DON'T LIVE HERE

The next time you discover your juveniles "playing doctor," give them a scalpel! Trust us, they know more than you. Because...

ALL I EVER NEEDED TO KNOW I LEARNED FROM INJECTING PLUTONIUM ISOTOPES INTO KINDERGARTNERS

Foolish earthlings! You spend multiple earth years in "higher" forms of education, but according to our research, all you really need to know you learned in kindergarten! Why else would your pupal instructors be paid such exorbitant sums of currency? So the next time your hatchling screams in your ear, pay attention! **For it knows more than you!**

ALL I EVER NEEDED TO KNOW I LEARNED FROM INJECTING PLUTONIUM ISOTOPES INTO KINDERGARTNERS

I LEARNED TO CONSTRUCT A NERVE RAY WITH GLITTER AND MACARONI!

I LEARNED TO EAT THINGS OFF THE FLOOR!

BY KANGY AND KODY

HOURS OF OBSERVATIONS OF THE MICRO-PANTSED.

THE CHILDREN ARE OUR FUTURE*!!!

SEE DICK. SEE JANE. FEAR THEM!!

REMEMBER:

LEARN ONLY FROM KINDERGARTNERS! DO NOT LISTEN TO FIRST GRADERS AS ALL THEY KNOW IS HOW TO BUILD AN ANTI-RIGELIAN DEFENSE CANNON! HA! WHAT NONSENSE!

AVOID FIRST GRADERS!!!

YOU WILL LEARN:
Screaming gets you graham crackers.
Nap time is when my enemy is asleep.
Your new god is a vengeful god, a god named "Hello Kitty!"
Crayons make for festive stool.

meals

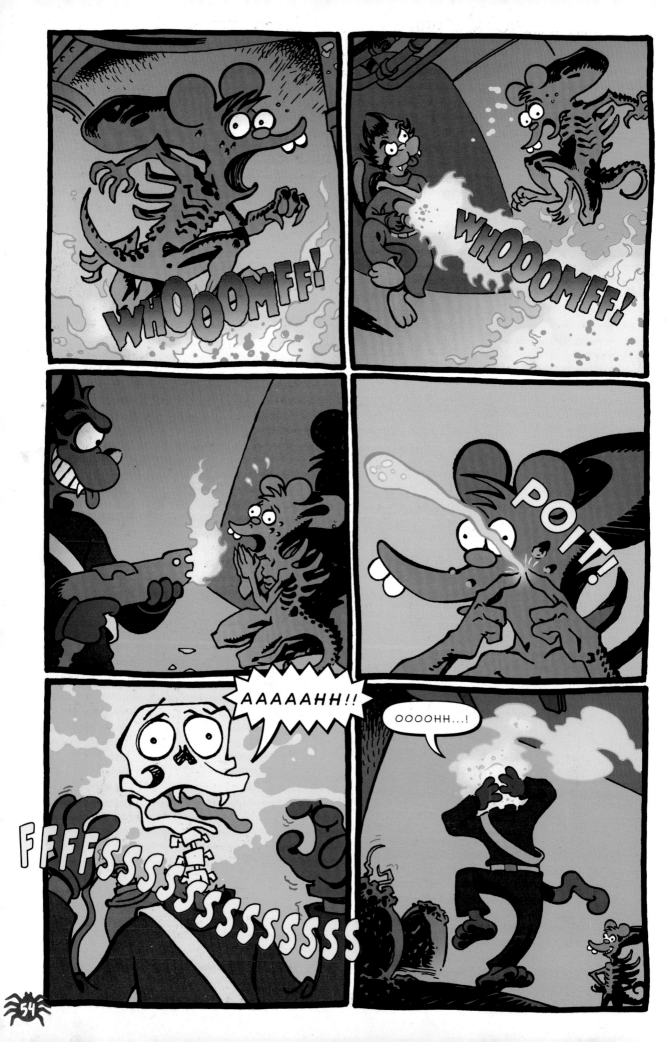

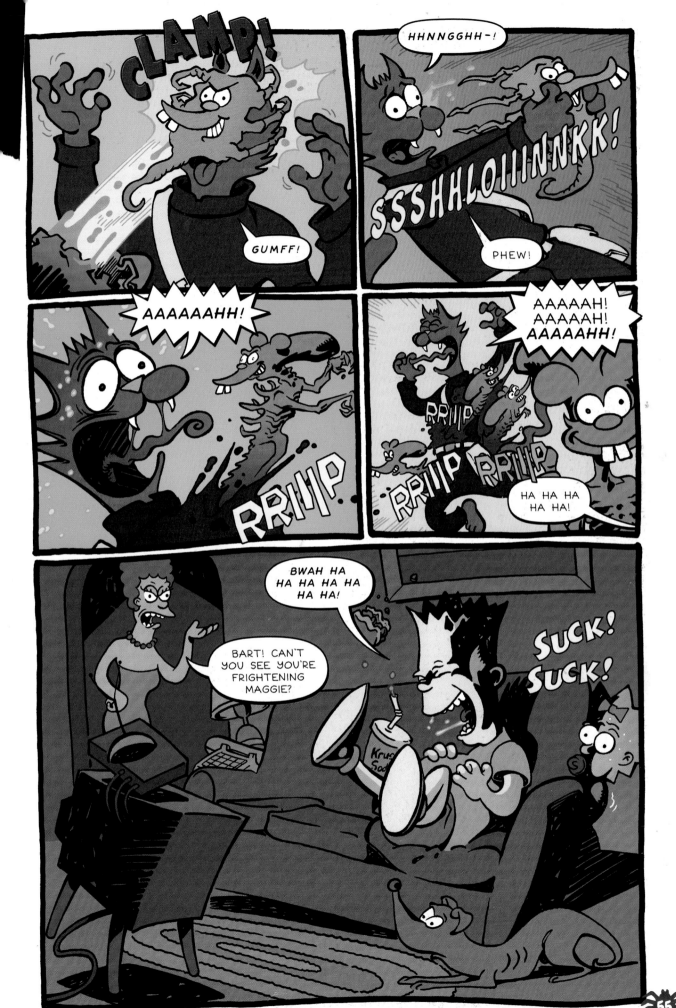

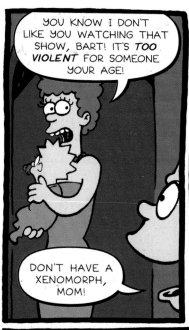

YOU KNOW I DON'T LIKE YOU WATCHING THAT SHOW, BART! IT'S *TOO VIOLENT* FOR SOMEONE YOUR AGE!

DON'T HAVE A XENOMORPH, MOM!

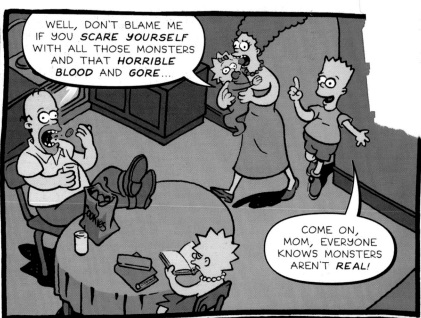

WELL, DON'T BLAME ME IF YOU *SCARE YOURSELF* WITH ALL THOSE MONSTERS AND THAT *HORRIBLE BLOOD* AND GORE...

COME ON, MOM, EVERYONE KNOWS MONSTERS AREN'T *REAL!*

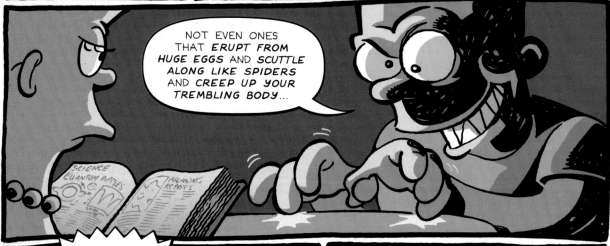

NOT EVEN ONES THAT *ERUPT FROM HUGE EGGS* AND *SCUTTLE ALONG LIKE SPIDERS* AND *CREEP UP YOUR TREMBLING BODY*...

SCIENCE
QUANTUM RIDDLES
ARACHNIDS ROBOTS

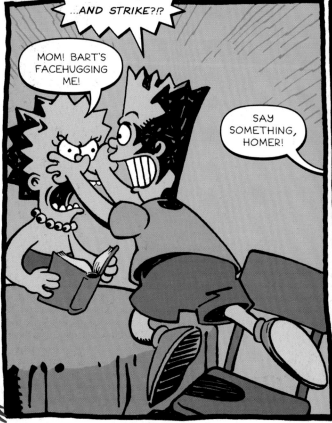

...AND STRIKE?!?

MOM! BART'S FACEHUGGING ME!

SAY SOMETHING, HOMER!

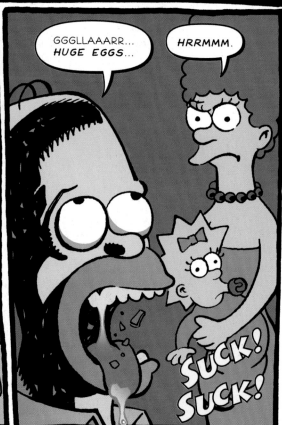

GGGLLAAARR... *HUGE EGGS...*

HRRMMM.

SUCK! SUCK!

56

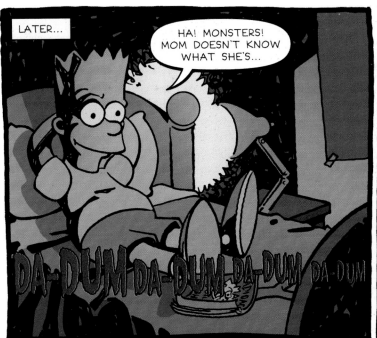

LATER...

HA! MONSTERS! MOM DOESN'T KNOW WHAT SHE'S...

DA-DUM DA-DUM DA-DUM DA-DUM

?

DA-DUM DA-DUM

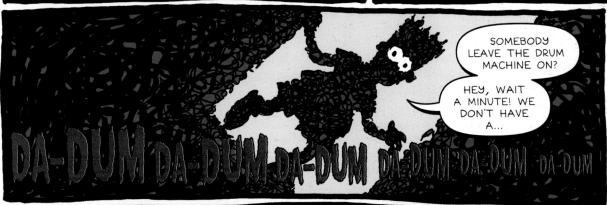

SOMEBODY LEAVE THE DRUM MACHINE ON?

HEY, WAIT A MINUTE! WE DON'T HAVE A...

DA-DUM DA-DUM DA-DUM DA-DUM DA-DUM DA-DUM

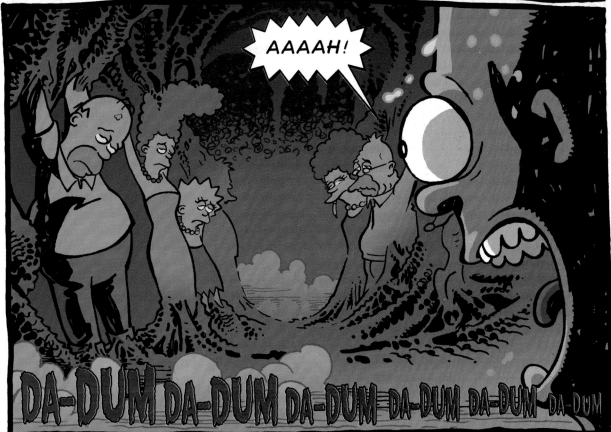

AAAAH!

DA-DUM DA-DUM DA-DUM DA-DUM DA-DUM DA-DUM

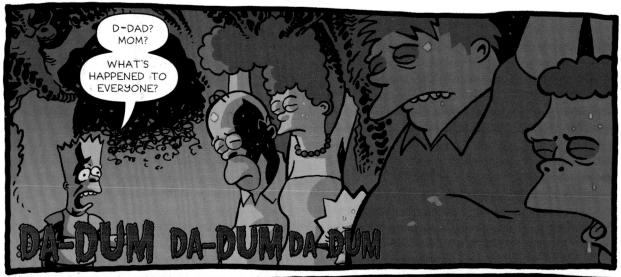

DA-DUM DA-DUM DA-DUM

DA-DUM DA-DUM DA-DUM

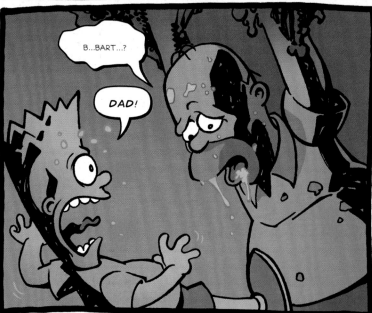

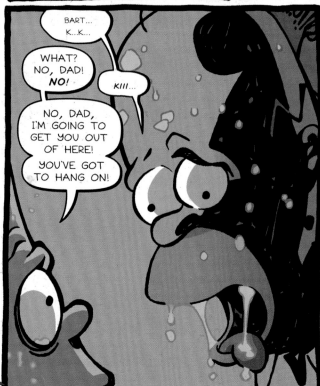

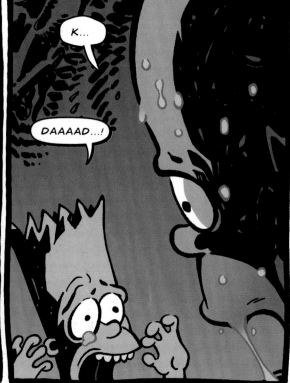

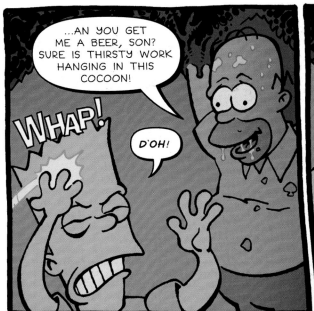

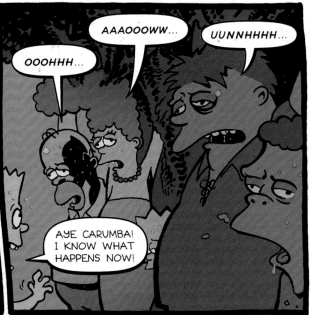

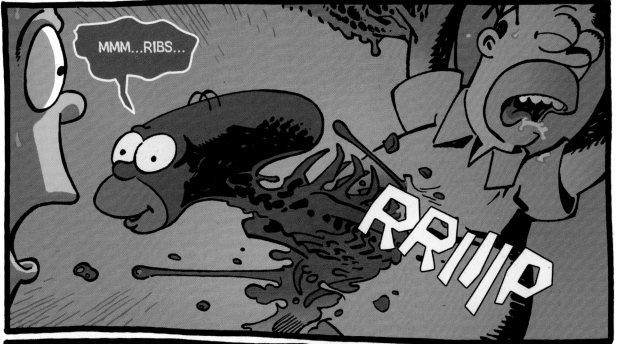

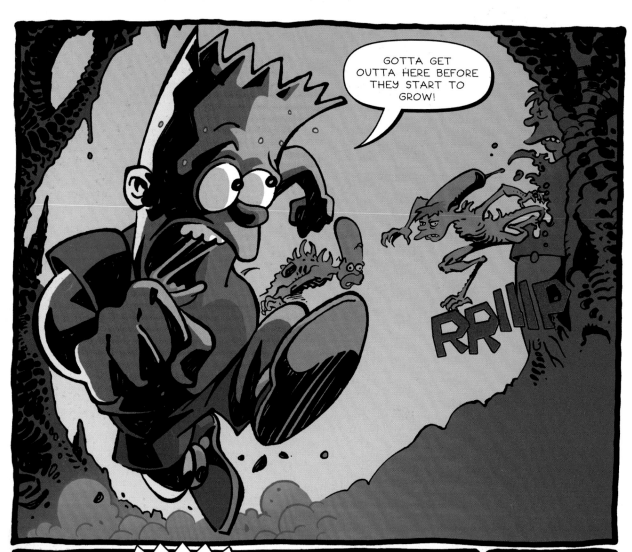

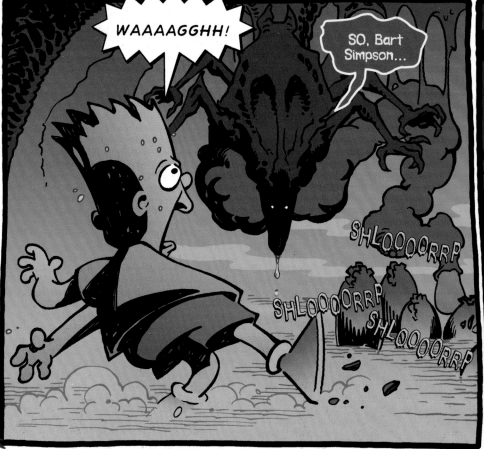

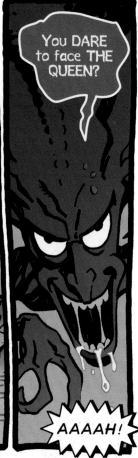

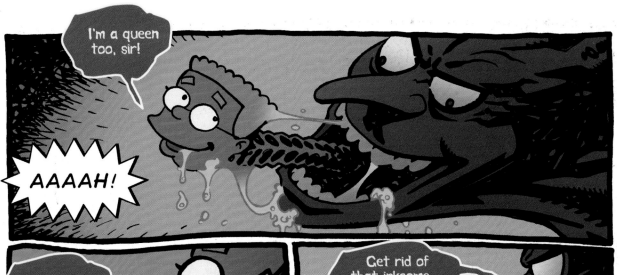

I'm a queen too, sir!

AAAAH!

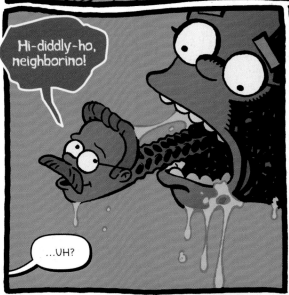

Hi-diddly-ho, neighborino!

...UH?

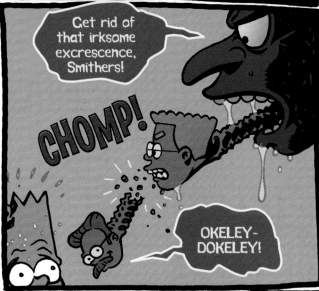

Get rid of that irksome excrescence, Smithers!

CHOMP!

OKELEY-DOKELEY!

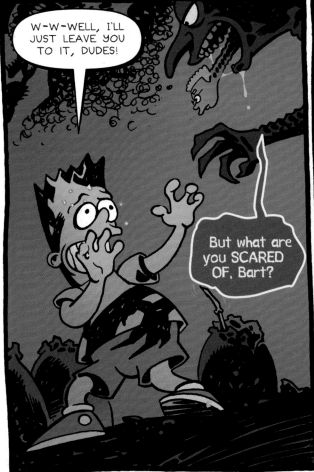

W-W-WELL, I'LL JUST LEAVE YOU TO IT, DUDES!

But what are you SCARED OF, Bart?

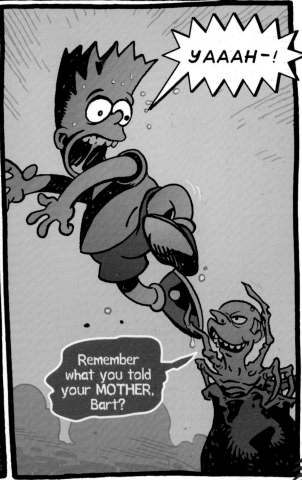

YAAAH-!

Remember what you told your MOTHER, Bart?

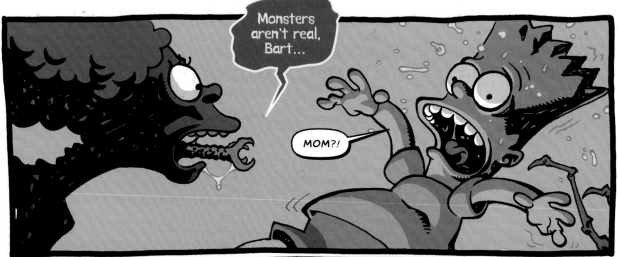

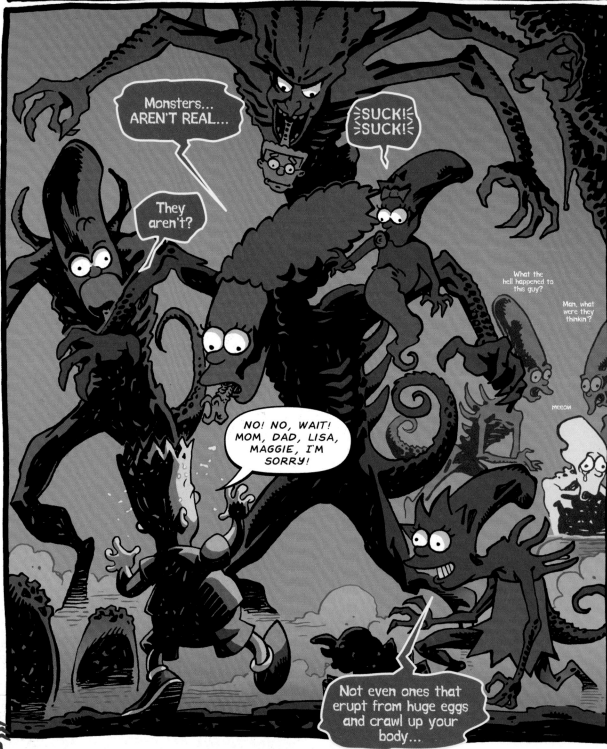

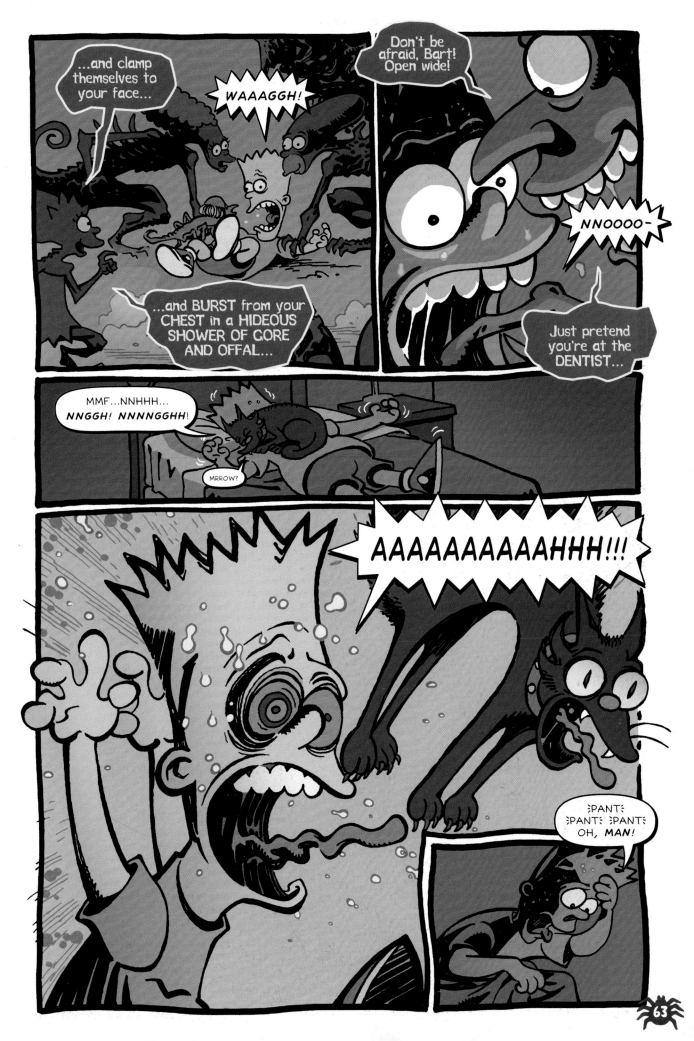

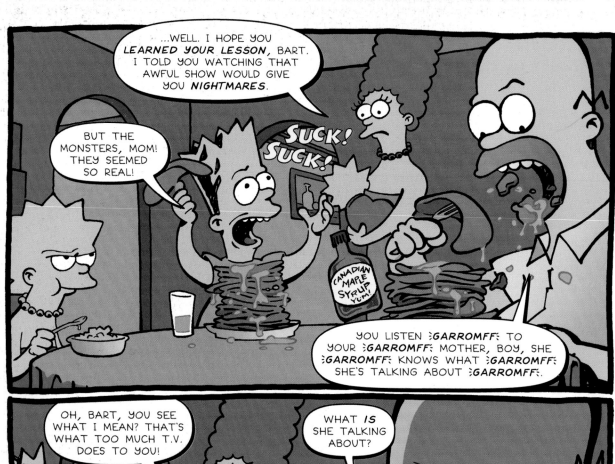

...WELL. I HOPE YOU *LEARNED YOUR LESSON*, BART. I TOLD YOU WATCHING THAT AWFUL SHOW WOULD GIVE YOU *NIGHTMARES*.

BUT THE MONSTERS, MOM! THEY SEEMED SO REAL!

SUCK! SUCK!

CANADIAN MAPLE SYRUP YUM!

YOU LISTEN ⊰GARROMFF⊱ TO YOUR ⊰GARROMFF⊱ MOTHER, BOY, SHE ⊰GARROMFF⊱ KNOWS WHAT ⊰GARROMFF⊱ SHE'S TALKING ABOUT ⊰GARROMFF⊱.

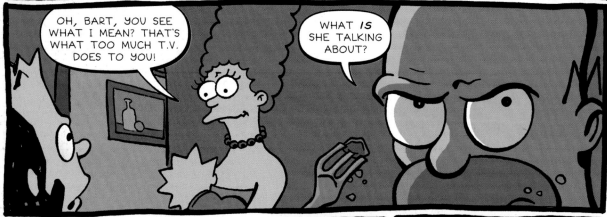

OH, BART, YOU SEE WHAT I MEAN? THAT'S WHAT TOO MUCH T.V. DOES TO YOU!

WHAT *IS* SHE TALKING ABOUT?

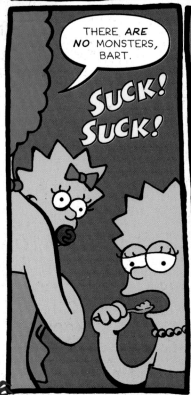

THERE *ARE* *NO* MONSTERS, BART.

SUCK! SUCK!

NO *REAL* ONES.

SUCK! SUCK!

SUCK! SUCK!

DA-DUM DA-DUM

THE END

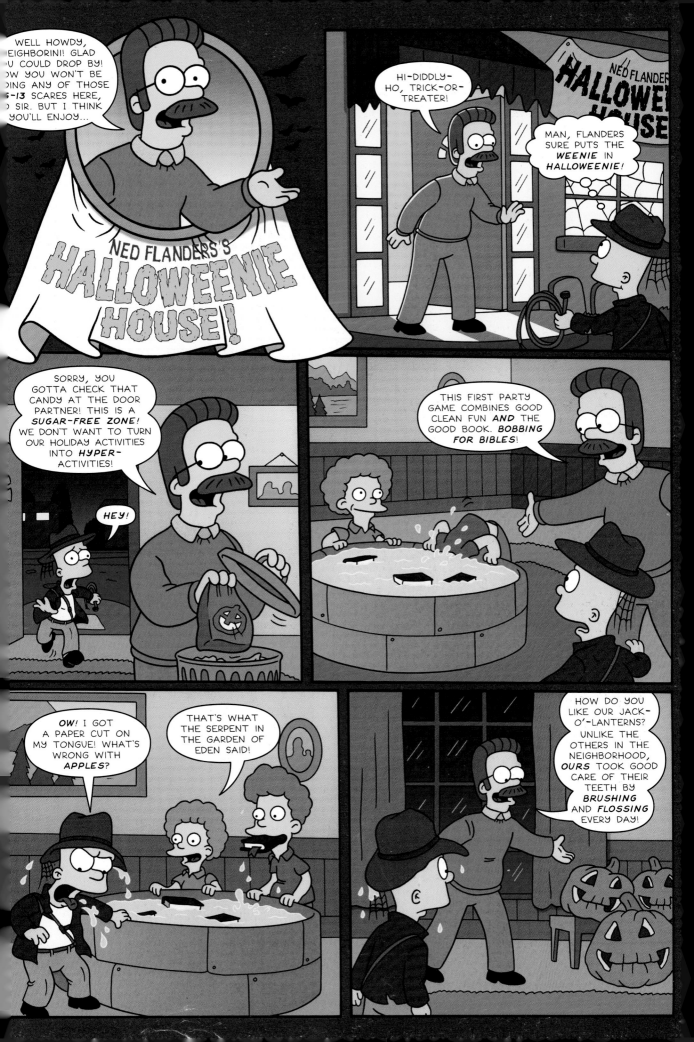

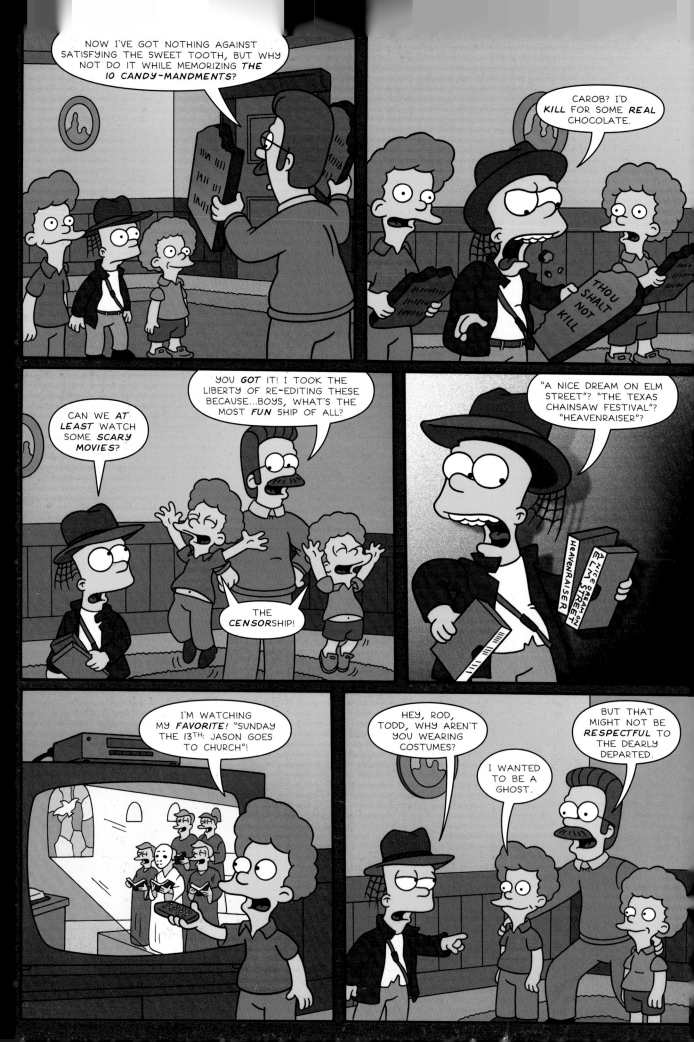

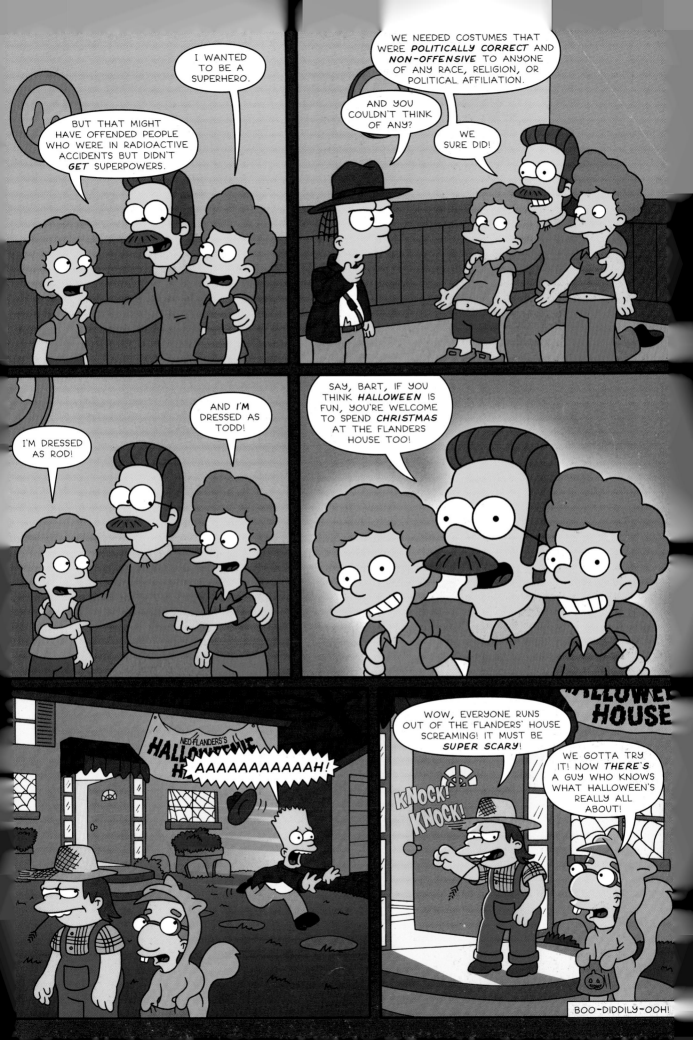

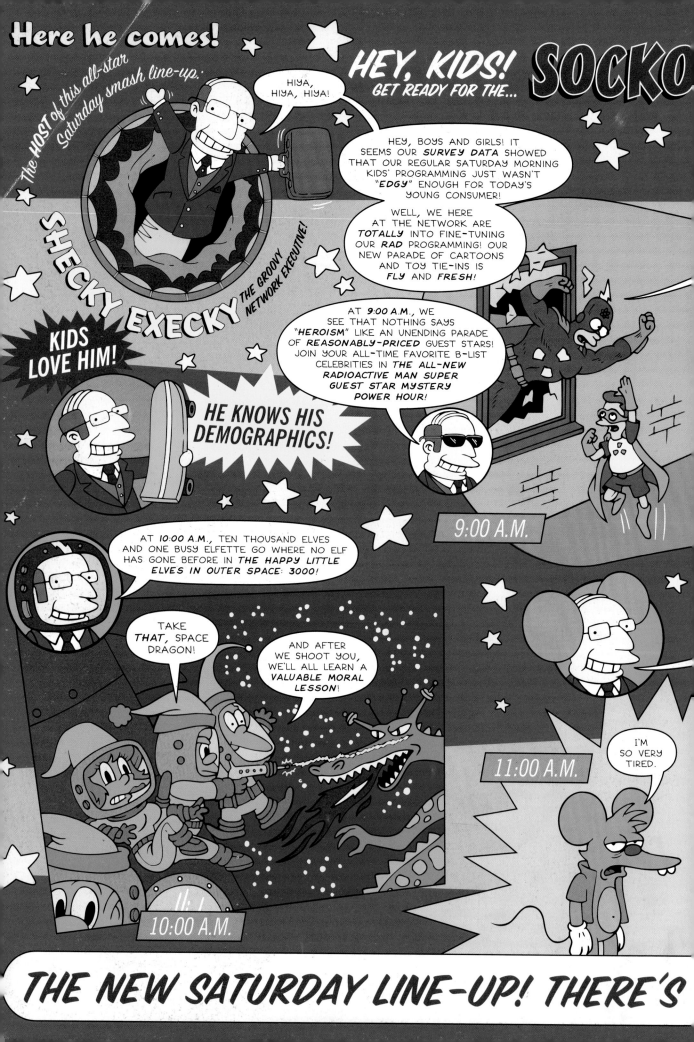

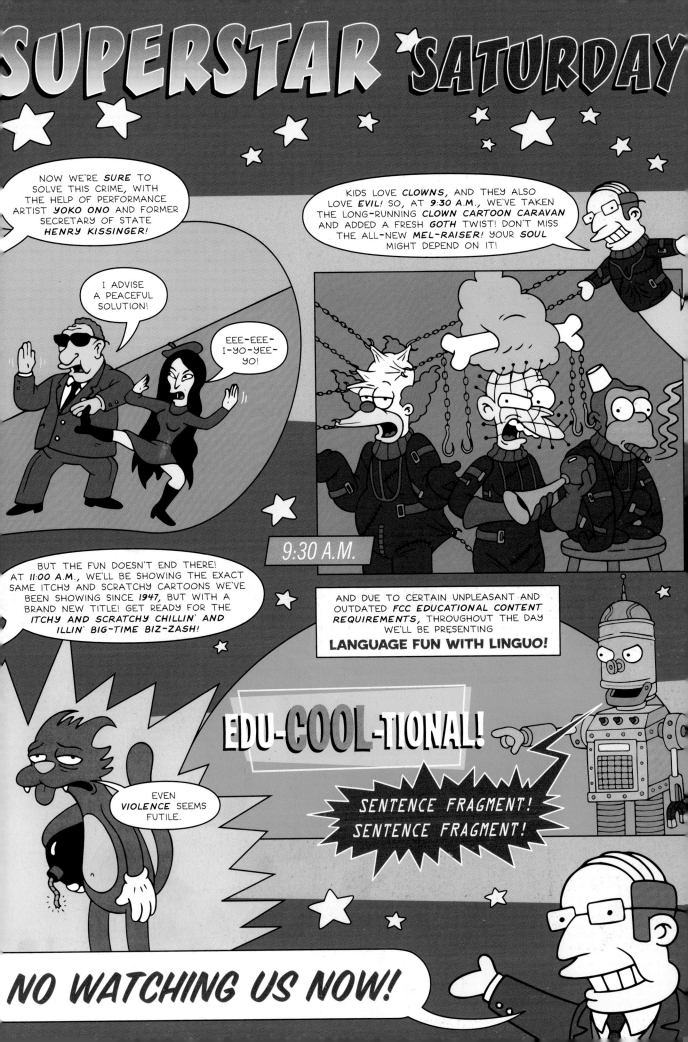

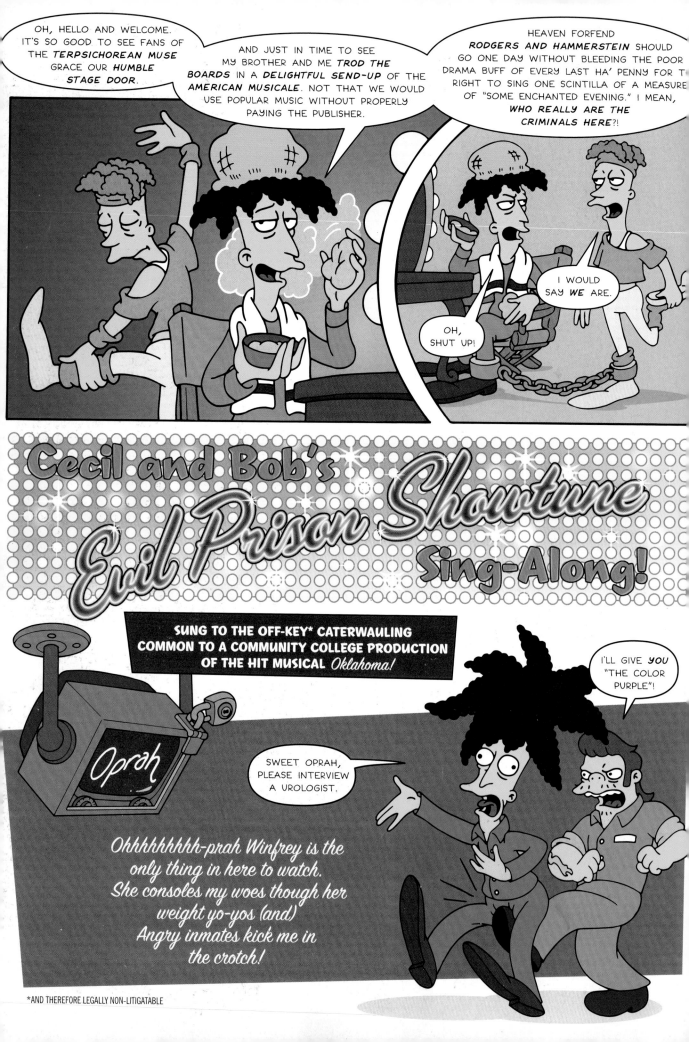

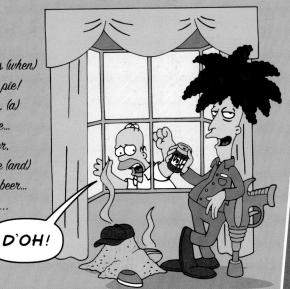

"Doh!" the sound a father makes (when)
"Ray" guns cook his son like pie!
"Me" is who will dance a jig. (a)
"Fop"pish twinkle in my eye...
"So" I let out a small cheer.
"Lock" his dad out of his house (and)
"Tease" him drinking his last beer...
that will bring us back to...

D'OH!

Raindrops on roses
And whiskers on kittens.
Bright copper kettles
And warm woolen mittens.
A new fifty-two-inch TV with remote.
These are the things
I would shove down Bart's throat!

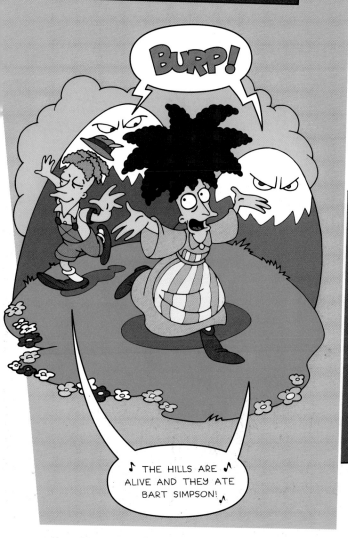

BURP!

♪ THE HILLS ARE ALIVE AND THEY ATE BART SIMPSON! ♪

I TOLD YOU BEFORE, WE WILL *NOT* BE DOING ANYTHING FROM *"COP ROCK"*!

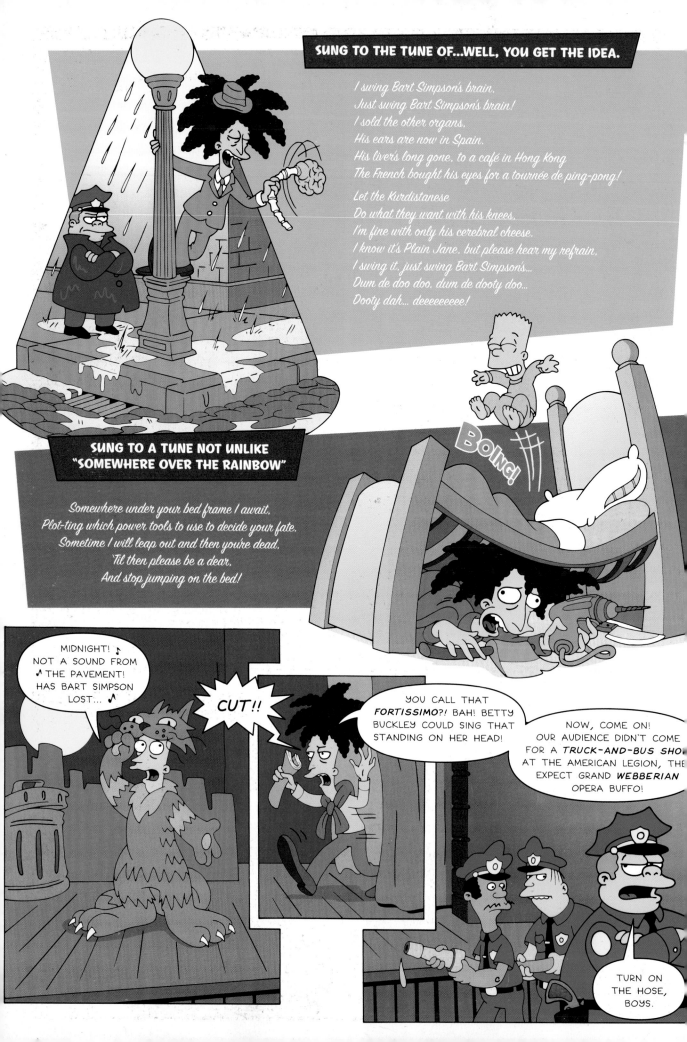

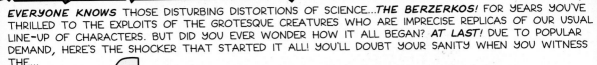

EVERYONE KNOWS THOSE DISTURBING DISTORTIONS OF SCIENCE...**THE BERZERKOS!** FOR YEARS YOU'VE THRILLED TO THE EXPLOITS OF THE GROTESQUE CREATURES WHO ARE IMPRECISE REPLICAS OF OUR USUAL LINE-UP OF CHARACTERS. BUT DID YOU EVER WONDER HOW IT ALL BEGAN? **AT LAST!** DUE TO POPULAR DEMAND, HERE'S THE SHOCKER THAT STARTED IT ALL! YOU'LL DOUBT YOUR SANITY WHEN YOU WITNESS THE...

CATASTROPHE in SUBSTITUTE SPRINGFIELDS!

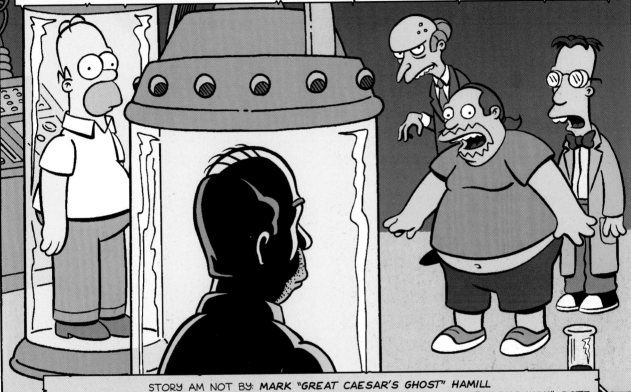

STORY AM NOT BY: **MARK "GREAT CAESAR'S GHOST" HAMILL**
ART AM NOT BY: **BACKWARD BILL MORRISON, JASON "BIZARRE" HO, MIKE "WRONG WAY" ROTE**
COLORS AM NOT BY: **ART "VILLAIN"UEVA** LETTERING AM NOT BY: **KAREN "BRAINIAC" BATES**
DESTROYER OF WORLDS: **ANTI-MATTER GROENING**

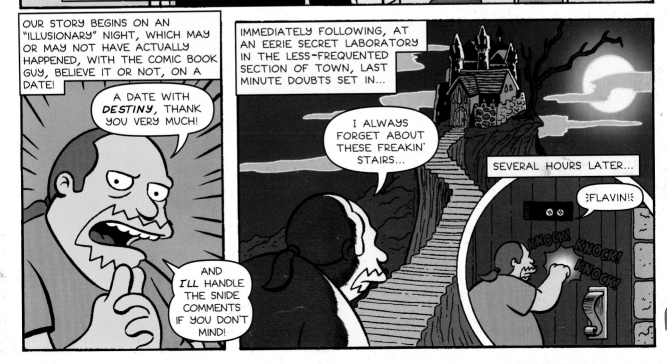

OUR STORY BEGINS ON AN "ILLUSIONARY" NIGHT, WHICH MAY OR MAY NOT HAVE ACTUALLY HAPPENED, WITH THE COMIC BOOK GUY, BELIEVE IT OR NOT, ON A DATE!

A DATE WITH *DESTINY*, THANK YOU VERY MUCH!

AND *I'LL* HANDLE THE SNIDE COMMENTS IF YOU DON'T MIND!

IMMEDIATELY FOLLOWING, AT AN EERIE SECRET LABORATORY IN THE LESS-FREQUENTED SECTION OF TOWN, LAST MINUTE DOUBTS SET IN...

I ALWAYS FORGET ABOUT THESE FREAKIN' STAIRS...

SEVERAL HOURS LATER...

=FLAVIN!=

KNOCK! KNOCK! KNOCK!

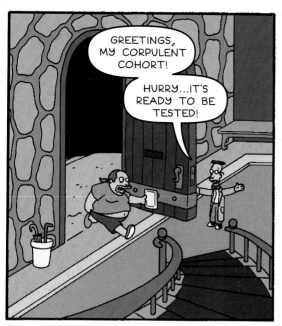

GREETINGS, MY CORPULENT COHORT!

HURRY...IT'S READY TO BE TESTED!

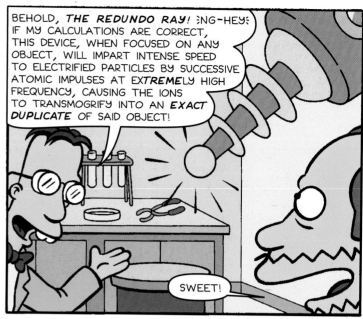

BEHOLD, *THE REDUNDO RAY!* ⚡NG-HEY⚡ IF MY CALCULATIONS ARE CORRECT, THIS DEVICE, WHEN FOCUSED ON ANY OBJECT, WILL IMPART INTENSE SPEED TO ELECTRIFIED PARTICLES BY SUCCESSIVE ATOMIC IMPULSES AT EX*TREME*LY HIGH FREQUENCY, CAUSING THE IONS TO TRANSMOGRIFY INTO AN *EXACT DUPLICATE* OF SAID OBJECT!

SWEET!

COME TO POPPA...

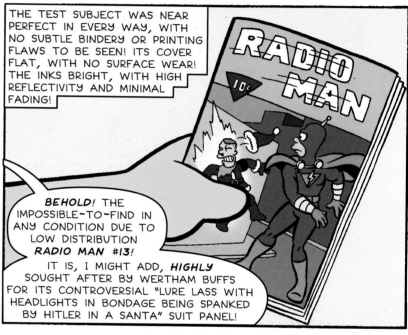

THE TEST SUBJECT WAS NEAR PERFECT IN EVERY WAY, WITH NO SUBTLE BINDERY OR PRINTING FLAWS TO BE SEEN! ITS COVER FLAT, WITH NO SURFACE WEAR! THE INKS BRIGHT, WITH HIGH REFLECTIVITY AND MINIMAL FADING!

RADIO MAN 10¢

BEHOLD! THE IMPOSSIBLE-TO-FIND IN ANY CONDITION DUE TO LOW DISTRIBUTION *RADIO MAN #13!*

IT IS, I MIGHT ADD, *HIGHLY* SOUGHT AFTER BY WERTHAM BUFFS FOR ITS CONTROVERSIAL "LURE LASS WITH HEADLIGHTS IN BONDAGE BEING SPANKED BY HITLER IN A SANTA" SUIT PANEL!

⚡KE-*FAU*-VER!⚡ HOW WELL I REMEMBER THAT SAUCY TEMPTRESS! WHY, ONE HOT SUMMER NIGHT IN PARTICULAR--

JUST *ZAP IT,* ALREADY!

A FURIOUS CRACKLE OF ENERGY...

BN-DRRRRR!

...A THUNDEROUS FLASH OF LIGHT...

...THEN SILENCE. YOU COULD HAVE HEARD A PIN DROP IF SOMEONE HAD BROUGHT A PIN, THEN DROPPED IT.

THERE IT WAS IN ALL ITS FOUR-COLOR GLORY--AN *EXACT DUPLICATE!* ITS COVER GLOSS AND LUSTER *INDISTINGUISHABLE* FROM THE ORIGINAL!

OH, *RAPTURE!* OH, *JOY!* C'MERE, YOU TWERPY LITTLE HUNK OF *GENIUS!*

OH, PAIN! MY POCKET PROTECTOR IS CRUSHING MY WINDPIPE!

BOTH MEN WERE ELATED, OVERWHELMED AT THE RAMIFICATIONS OF THIS STRANGE DEVICE!

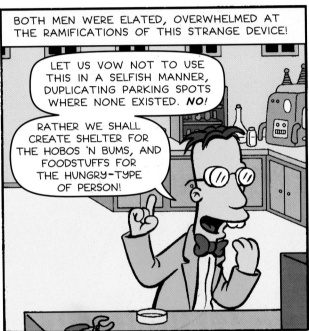

LET US VOW NOT TO USE THIS IN A SELFISH MANNER, DUPLICATING PARKING SPOTS WHERE NONE EXISTED. *NO!*

RATHER WE SHALL CREATE SHELTER FOR THE HOBOS 'N BUMS, AND FOODSTUFFS FOR THE HUNGRY-TYPE OF PERSON!

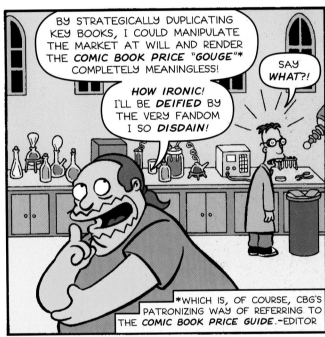

BY STRATEGICALLY DUPLICATING KEY BOOKS, I COULD MANIPULATE THE MARKET AT WILL AND RENDER THE *COMIC BOOK PRICE "GOUGE"** COMPLETELY MEANINGLESS!

HOW IRONIC! I'LL BE *DEIFIED* BY THE VERY FANDOM I SO *DISDAIN!*

SAY *WHAT?!*

*WHICH IS, OF COURSE, CBG'S PATRONIZING WAY OF REFERRING TO THE *COMIC BOOK PRICE GUIDE.*-EDITOR

A CLASH OF TITANIC EGOS, AS THE PARTNERS LET INVECTIVE FLY!

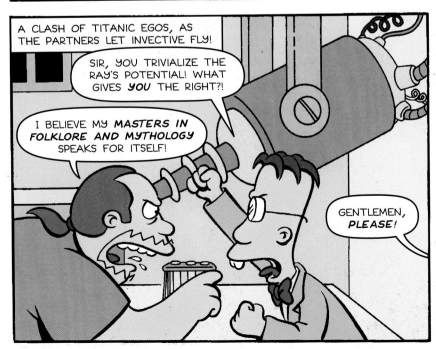

SIR, YOU TRIVIALIZE THE RAY'S POTENTIAL! WHAT GIVES *YOU* THE RIGHT?!

I BELIEVE MY *MASTERS IN FOLKLORE AND MYTHOLOGY* SPEAKS FOR ITSELF!

GENTLEMEN, *PLEASE!*

I MUST ASK THAT YOU VACATE THE PREMISES IMMEDIATELY!

I HEREBY DECLARE WHAT I OVERHEARD YOU REFER TO AS "THE REDUNDO RAY" THE SOLE INTELLECTUAL PROPERTY OF MY CLIENT...

...C. MONTGOMERY BURNS!*

DON'T MIND MY GOONS AS THEY RANSACK YOUR EQUIPMENT AND SEIZE EVERY THING IN SIGHT...

...IT'S ALL MINE!

*WHO, BY SHEER COINCIDENCE, WAS PASSING BY THE REMOTE LABORATORY AT THE PRECISE MOMENT OF THEIR SCIENTIFIC TRIUMPH. –EDITOR

MOMENTS LATER...

《SOB》 IT'S ALL TRUE! HOW COULD I RESIST, WHAT WITH THE UNLIMITED FUNDING, THE RARE RADIOACTIVE ISOTOPE...THE COMPREHENSIVE DENTAL PLAN!

SENSES REELING...

...GASTRIC FLUIDS CHURNING...

...UNABLE TO CONTAIN URGE TO EXPRESS GUT-WRENCHING RAGE AT ITS MOST PRIMAL...

AND SO...

EEEAAAUGGGH!

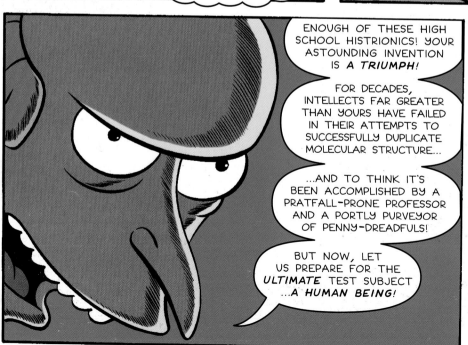

ENOUGH OF THESE HIGH SCHOOL HISTRIONICS! YOUR ASTOUNDING INVENTION IS A TRIUMPH!

FOR DECADES, INTELLECTS FAR GREATER THAN YOURS HAVE FAILED IN THEIR ATTEMPTS TO SUCCESSFULLY DUPLICATE MOLECULAR STRUCTURE...

...AND TO THINK IT'S BEEN ACCOMPLISHED BY A PRATFALL-PRONE PROFESSOR AND A PORTLY PURVEYOR OF PENNY-DREADFULS!

BUT NOW, LET US PREPARE FOR THE ULTIMATE TEST SUBJECT ...A HUMAN BEING!

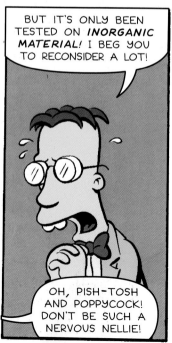

BUT IT'S ONLY BEEN TESTED ON INORGANIC MATERIAL! I BEG YOU TO RECONSIDER A LOT!

OH, PISH-TOSH AND POPPYCOCK! DON'T BE SUCH A NERVOUS NELLIE!

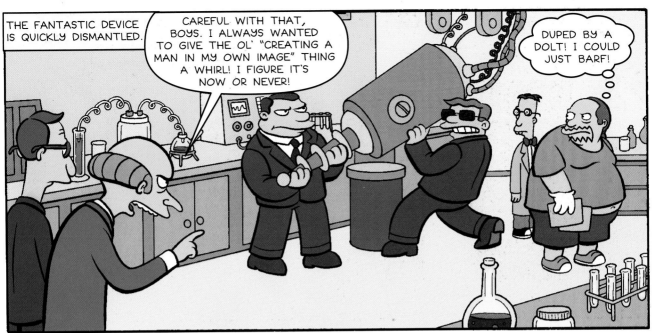

THE FANTASTIC DEVICE IS QUICKLY DISMANTLED.

CAREFUL WITH THAT, BOYS. I ALWAYS WANTED TO GIVE THE OL' "CREATING A MAN IN MY OWN IMAGE" THING A WHIRL! I FIGURE IT'S NOW OR NEVER!

DUPED BY A DOLT! I COULD JUST BARF!

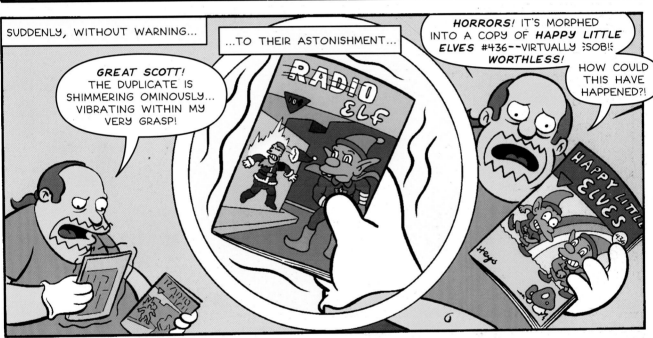

SUDDENLY, WITHOUT WARNING...

...TO THEIR ASTONISHMENT...

GREAT SCOTT! THE DUPLICATE IS SHIMMERING OMINOUSLY... VIBRATING WITHIN MY VERY GRASP!

HORRORS! IT'S MORPHED INTO A COPY OF *HAPPY LITTLE ELVES* #436--VIRTUALLY ⊏SOB!⊐ *WORTHLESS!*

HOW COULD THIS HAVE HAPPENED?!

RADIO ELF

HAPPY LITTLE ELVES

PERHAPS *I* CAN EXPLAIN! CLEARLY, THE EXACT DUPLICATE HAS DESTABILIZED INTO AN "IMPRECISE REPLICA"! WHEN THE HIGHLY CHARGED *DNA*, ALREADY IN AN AGITATED STATE OF FLUX, CAME IN CONTACT WITH THE HARD WATER PARTICLES IN OUR ATMOSPHERE,

IT *DISTORTED* LIKE A REFLECTION IN A FUN-HOUSE MIRROR!

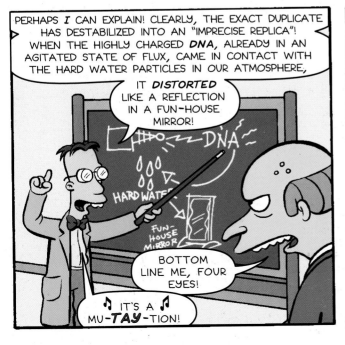

DNA

HARD WATER

FUN-HOUSE MIRROR

BOTTOM LINE ME, FOUR EYES!

♪ IT'S A ♪ MU-*TAY*-TION!

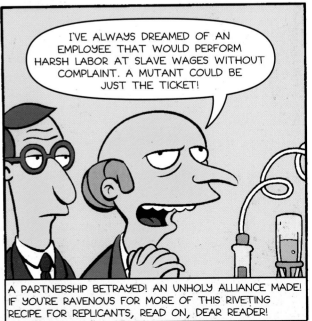

I'VE ALWAYS DREAMED OF AN EMPLOYEE THAT WOULD PERFORM HARSH LABOR AT SLAVE WAGES WITHOUT COMPLAINT. A MUTANT COULD BE JUST THE TICKET!

A PARTNERSHIP BETRAYED! AN UNHOLY ALLIANCE MADE! IF YOU'RE RAVENOUS FOR MORE OF THIS RIVETING RECIPE FOR REPLICANTS, READ ON, DEAR READER!

AFTER NEARLY A WEEK OF INTENSIVE TESTING, THE MOMENTOUS OCCASION WAS AT HAND!

ALL SYSTEMS ARE GO, SIR. TODAY'S THE DAY WE MAKE ‹GASP› *A MAN!*

EXCELLENT! YOU'VE SHOWN A PARTICULAR ENTHUSIASM FOR THE PROJECT THAT IS MOST COMMENDABLE, SMITHERS!

WHO WILL BE OUR FIRST TEST SUBJECT?

THE SELECTION PROCESS WAS OF PARAMOUNT IMPORTANCE, SIR--INSURING US A MUTANT WE CAN ALL LIVE WITH!

RESEARCH AND DEVELOPMENT

WITH THE TOUCH OF A SECRET BUTTON, A WALL PANEL SLID BACK TO REVEAL...

...A LAVISHLY EQUIPPED SUBTERRANEAN RESEARCH AND DEVELOPMENT COMPLEX, BUSTLING WITH ACTIVITY.

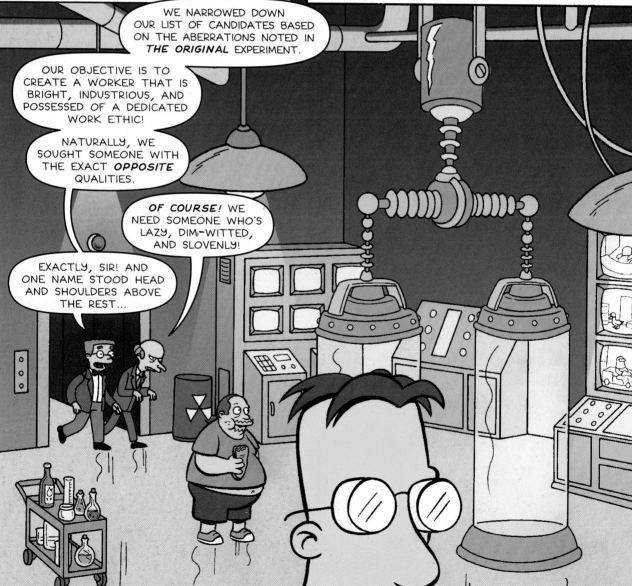

WE NARROWED DOWN OUR LIST OF CANDIDATES BASED ON THE ABERRATIONS NOTED IN *THE ORIGINAL* EXPERIMENT.

OUR OBJECTIVE IS TO CREATE A WORKER THAT IS BRIGHT, INDUSTRIOUS, AND POSSESSED OF A DEDICATED WORK ETHIC!

NATURALLY, WE SOUGHT SOMEONE WITH THE EXACT *OPPOSITE* QUALITIES.

OF COURSE! WE NEED SOMEONE WHO'S LAZY, DIM-WITTED, AND SLOVENLY!

EXACTLY, SIR! AND ONE NAME STOOD HEAD AND SHOULDERS ABOVE THE REST...

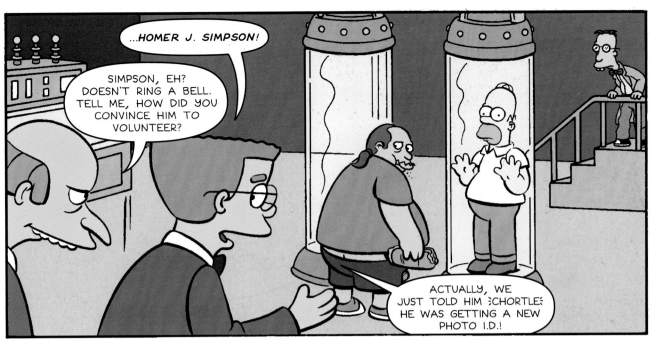

...HOMER J. SIMPSON!

SIMPSON, EH? DOESN'T RING A BELL. TELL ME, HOW DID YOU CONVINCE HIM TO VOLUNTEER?

ACTUALLY, WE JUST TOLD HIM ‹CHORTLE› HE WAS GETTING A NEW PHOTO I.D.!

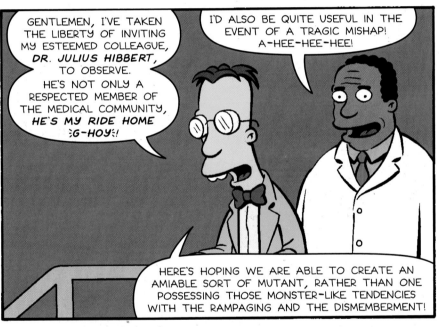

GENTLEMEN, I'VE TAKEN THE LIBERTY OF INVITING MY ESTEEMED COLLEAGUE, *DR. JULIUS HIBBERT*, TO OBSERVE. HE'S NOT ONLY A RESPECTED MEMBER OF THE MEDICAL COMMUNITY, *HE'S MY RIDE HOME* ‹G-HOY!›

I'D ALSO BE QUITE USEFUL IN THE EVENT OF A TRAGIC MISHAP! A-HEE-HEE-HEE!

HERE'S HOPING WE ARE ABLE TO CREATE AN AMIABLE SORT OF MUTANT, RATHER THAN ONE POSSESSING THOSE MONSTER-LIKE TENDENCIES WITH THE RAMPAGING AND THE DISMEMBERMENT!

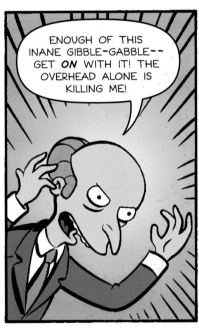

ENOUGH OF THIS INANE GIBBLE-GABBLE-- GET **ON** WITH IT! THE OVERHEAD ALONE IS KILLING ME!

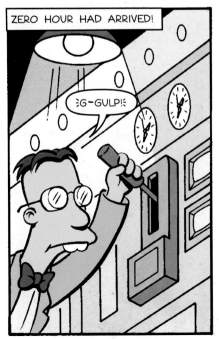

ZERO HOUR HAD ARRIVED!

‹G-GULP!›

SHH--KONK!

VWOOOOMMM

VR-R-RAKA -KRAKA!

AS THEIR EYES ADJUSTED TO THE BLINDING FLASHES OF WHITE-HOT ENERGY, THERE STOOD AN ABSOLUTE CARBON COPY!

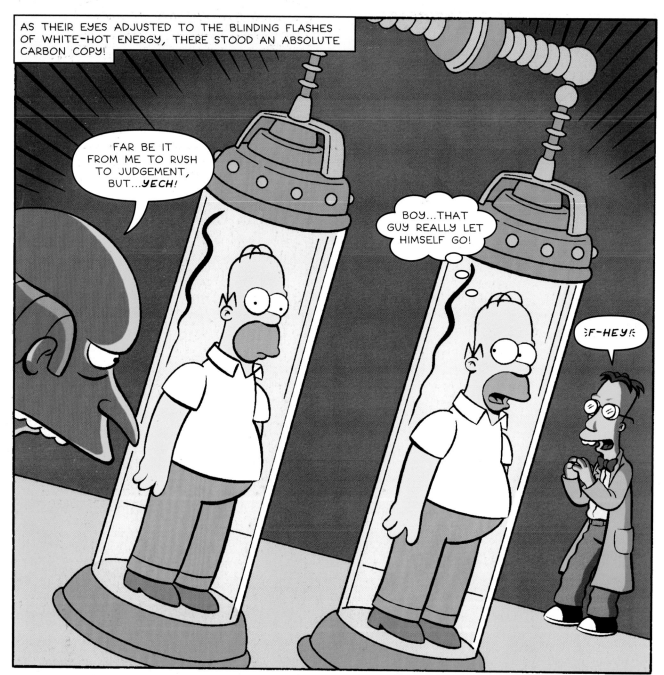

FAR BE IT FROM ME TO RUSH TO JUDGEMENT, BUT...*YECH!*

BOY...THAT GUY REALLY LET HIMSELF GO!

≥F-HEY!≥

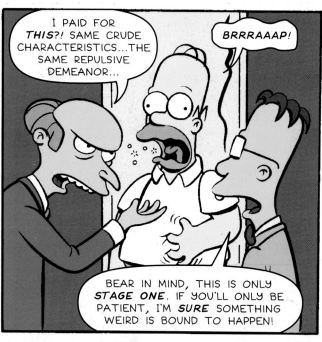

I PAID FOR *THIS*?! SAME CRUDE CHARACTERISTICS...THE SAME REPULSIVE DEMEANOR...

BRRRAAAP!

BEAR IN MIND, THIS IS ONLY *STAGE ONE*. IF YOU'LL ONLY BE PATIENT, I'M *SURE* SOMETHING WEIRD IS BOUND TO HAPPEN!

AND...AS IF IN MOCKING RESPONSE...

LOOK SIR, IT'S...≥SHUDDER≥ *MORPHING!*

LEAPIN' LYCANTHROPY!

A HARROWING TRANSFORMATION TAKES PLACE...

W-WHAT'S...HAPPENING...TO...ME?!

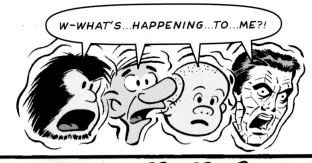

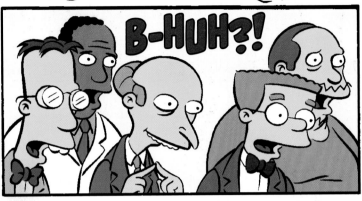

B-HUH?!

THE CREATURE WAS BREATHTAKING TO BEHOLD! HIS EYES BLAZING WITH RARE INTELLIGENCE, A LOCK OF HAIR CURLING RAKISHLY DOWN HIS FOREHEAD--HE STOOD LIKE A MAGNIFICENT COLOSSUS ASTRIDE TWO WORLDS!

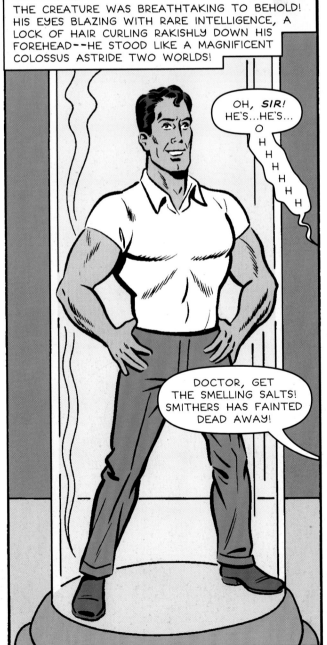

OH, SIR! HE'S...HE'S... OHHHHHHH

DOCTOR, GET THE SMELLING SALTS! SMITHERS HAS FAINTED DEAD AWAY!

BUT TO THE PROFESSOR'S TRAINED EYE, THE ANOMALIES WERE APPARENT.

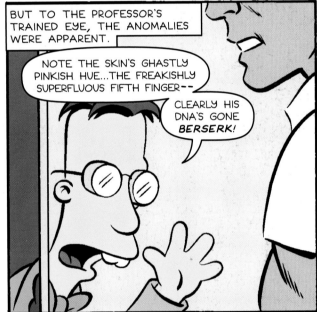

NOTE THE SKIN'S GHASTLY PINKISH HUE...THE FREAKISHLY SUPERFLUOUS FIFTH FINGER--

CLEARLY HIS DNA'S GONE BERSERK!

YOU...UH...CALLED ME -›MUMBLE‹- BERT-ZERKO? MUST BE MY NAME!

WITH A HISS OF STEAM, THE CHAMBER DOORS SWUNG OPEN...

HIIISSSSS!

WE MUST PROCEED WITH CAUTION! BUT BEWARE--REMEMBER, IT'S MADE OF NON-LIVING MATTER!

EVEN *NON*-LIVING MATTER NEEDS A PLACE TO STAY! MY GUESTROOM HASN'T BEEN TOUCHED SINCE *STACEYCON 2000!*

HE'S HUNKY ALRIGHT...BUT WHERE'S THE OLD SIMPSON CHARM?

HOLD YOUR HORSES, OLD BEAN. THERE WON'T BE ANY SLEEPOVERS FOR *YOU.* OR HAVE YOU FORGOTTEN TONIGHT'S OUR BI-ANNUAL PEDICURE JAMBOREE?!

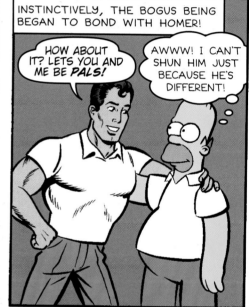

INSTINCTIVELY, THE BOGUS BEING BEGAN TO BOND WITH HOMER!

HOW ABOUT IT? LETS YOU AND ME BE *PALS!*

AWWW! I CAN'T SHUN HIM JUST BECAUSE HE'S DIFFERENT!

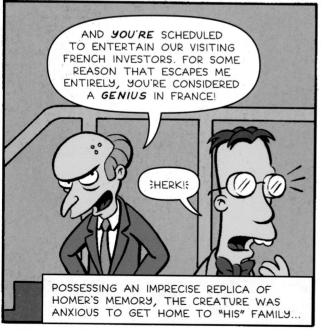

AND *YOU'RE* SCHEDULED TO ENTERTAIN OUR VISITING FRENCH INVESTORS. FOR SOME REASON THAT ESCAPES ME ENTIRELY, YOU'RE CONSIDERED A *GENIUS* IN FRANCE!

:HERK!:

POSSESSING AN IMPRECISE REPLICA OF HOMER'S MEMORY, THE CREATURE WAS ANXIOUS TO GET HOME TO "HIS" FAMILY...

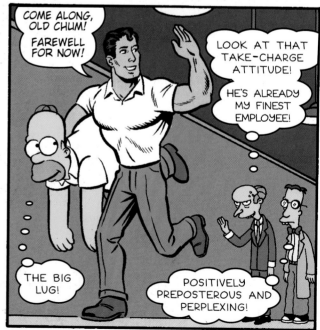

COME ALONG, OLD CHUM! FAREWELL FOR NOW!

LOOK AT THAT TAKE-CHARGE ATTITUDE!

HE'S ALREADY MY FINEST EMPLOYEE!

THE BIG LUG!

POSITIVELY PREPOSTEROUS AND PERPLEXING!

CHAOS REIGNS WHEN HOMER BRINGS HOME AN UNINVITED HOUSEGUEST! CHILLS, LAUGHS AND LUMP-IN-YOUR-THROAT PATHOS AWAIT YOU WHEN *"A FAMILY GOES BERZERK-D'OH!"*, IMMEDIATELY FOLLOWING!

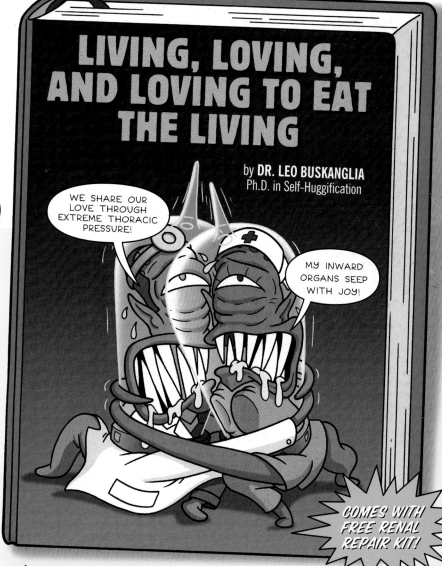

THAT NIGHT AT THE SIMPSON DINNER TABLE, AFTER A LENGTHY EXPLANATION...

SO TO RECAP, HE'S 29...SINGLE BUT LOOKING, WE'RE KINDA RELATED **AND** HE'S FROM A TOP-SECRET PROJECT DOWN AT WORK I'M NOT ALLOWED TO TALK ABOUT SO DON'T ASK ME.

NOW, CAN WE **PLEASE** WATCH SOME *TV*?

QUIETLY, FROM THE SHADOWS, BERT OBSERVED A TYPICAL SIMPSON'S EVENING AT HOME.

LOOK AT 'IM! HE'S REALLY GONNA *EAT* IT!

OH MY...

EE-YEW!

WE'LL RETURN TO *"WHEN STOMACH CONTENTS REBEL"*, AFTER THIS...

YOU CAN ALWAYS COUNT ON *FOX!*

WITNESSING THIS TOUCHING TABLEAU WAS ALMOST MORE THAN THE POOR MISFIT OF SCIENCE COULD BEAR...

NIGHT, NIGHT, MAGGIE...YOU'RE A LITTLE ANGEL.

YEAH ⸮SIGH⸮ NOT LIKE THE BOY.

WITH THE CREATURE'S RAPIDLY EXPANDING CONSCIOUSNESS CAME A PROFOUND SENSE OF SOLITUDE AND LONELINESS!

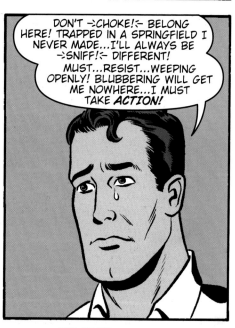

DON'T ⸮CHOKE!⸮ BELONG HERE! TRAPPED IN A SPRINGFIELD I NEVER MADE...I'LL ALWAYS BE ⸮SNIFF!⸮ DIFFERENT! MUST...RESIST...WEEPING OPENLY! BLUBBERING WILL GET ME NOWHERE...I MUST TAKE *ACTION!*

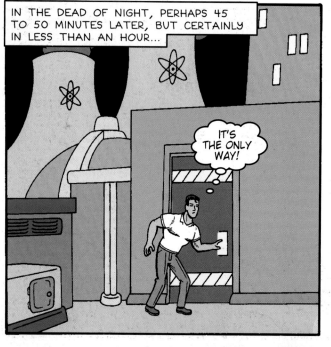

IN THE DEAD OF NIGHT, PERHAPS 45 TO 50 MINUTES LATER, BUT CERTAINLY IN LESS THAN AN HOUR...

IT'S THE ONLY WAY!

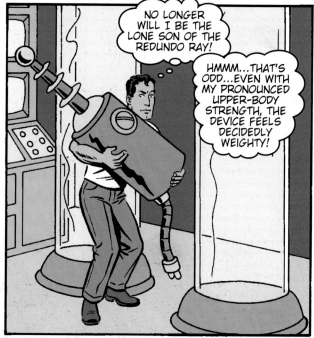

NO LONGER WILL I BE THE LONE SON OF THE REDUNDO RAY!

HMMM...THAT'S ODD...EVEN WITH MY PRONOUNCED UPPER-BODY STRENGTH, THE DEVICE FEELS DECIDEDLY WEIGHTY!

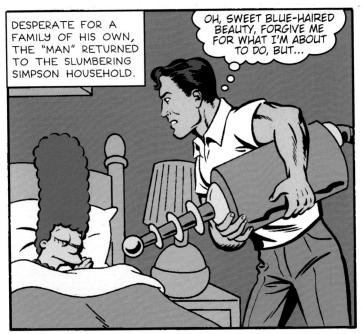

DESPERATE FOR A FAMILY OF HIS OWN, THE "MAN" RETURNED TO THE SLUMBERING SIMPSON HOUSEHOLD.

OH, SWEET BLUE-HAIRED BEAUTY, FORGIVE ME FOR WHAT I'M ABOUT TO DO, BUT...

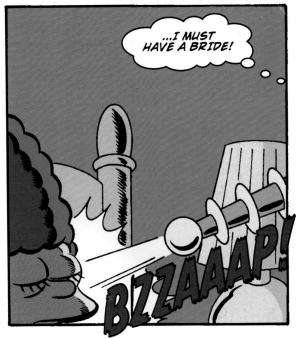

...I MUST HAVE A BRIDE!

BZZAAAP!

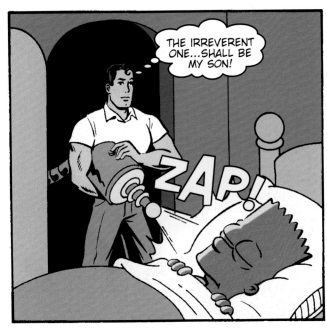

THE IRREVERENT ONE...SHALL BE MY SON!

ZAP!

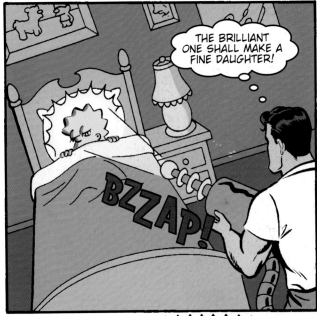

THE BRILLIANT ONE SHALL MAKE A FINE DAUGHTER!

BZZAP!

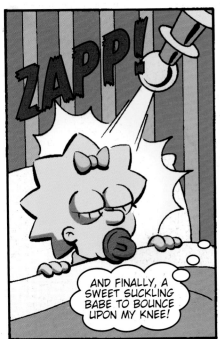

ZAPP!

AND FINALLY, A SWEET SUCKLING BABE TO BOUNCE UPON MY KNEE!

I'M CERTAIN THE SIMPSONS WILL LEARN TO LOVE THE ZERKO FAMILY ONCE THEY GET OVER THE INITIAL SHOCK.

YAAAUUGHHH!!

THAT SOUNDS LIKE THEIR STARTLED SCREAMS NOW!

85

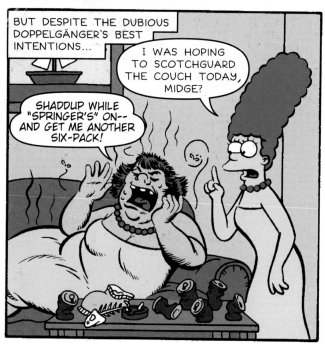

BUT DESPITE THE DUBIOUS DOPPELGÄNGER'S BEST INTENTIONS...

I WAS HOPING TO SCOTCHGUARD THE COUCH TODAY, MIDGE?

SHADDUP WHILE "SPRINGER'S" ON-- AND GET ME ANOTHER SIX-PACK!

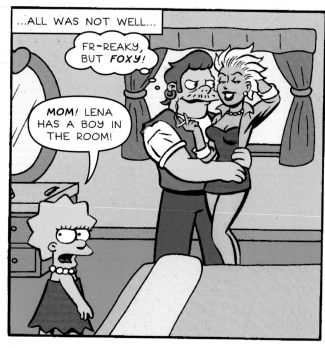

...ALL WAS NOT WELL...

FR-REAKY, BUT FOXY!

MOM! LENA HAS A BOY IN THE ROOM!

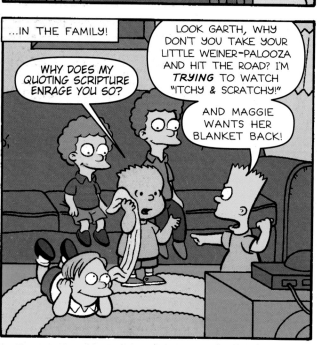

...IN THE FAMILY!

WHY DOES MY QUOTING SCRIPTURE ENRAGE YOU SO?

LOOK GARTH, WHY DON'T YOU TAKE YOUR LITTLE WEINER-PALOOZA AND HIT THE ROAD? I'M TRYING TO WATCH "ITCHY & SCRATCHY!"

AND MAGGIE WANTS HER BLANKET BACK!

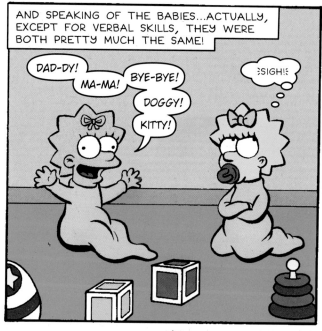

AND SPEAKING OF THE BABIES...ACTUALLY, EXCEPT FOR VERBAL SKILLS, THEY WERE BOTH PRETTY MUCH THE SAME!

DAD-DY!

MA-MA!

BYE-BYE!

DOGGY!

KITTY!

!SIGH!!

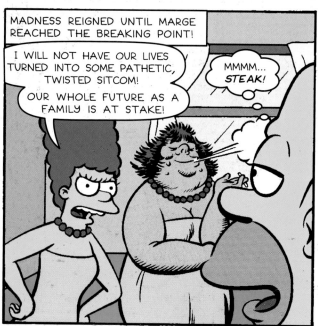

MADNESS REIGNED UNTIL MARGE REACHED THE BREAKING POINT!

I WILL NOT HAVE OUR LIVES TURNED INTO SOME PATHETIC, TWISTED SITCOM!

OUR WHOLE FUTURE AS A FAMILY IS AT STAKE!

MMMM... STEAK!

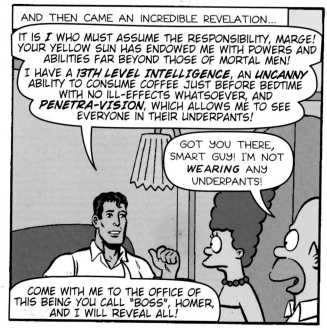

AND THEN CAME AN INCREDIBLE REVELATION...

IT IS I WHO MUST ASSUME THE RESPONSIBILITY, MARGE! YOUR YELLOW SUN HAS ENDOWED ME WITH POWERS AND ABILITIES FAR BEYOND THOSE OF MORTAL MEN! I HAVE A 13TH LEVEL INTELLIGENCE, AN UNCANNY ABILITY TO CONSUME COFFEE JUST BEFORE BEDTIME WITH NO ILL-EFFECTS WHATSOEVER, AND PENETRA-VISION, WHICH ALLOWS ME TO SEE EVERYONE IN THEIR UNDERPANTS!

GOT YOU THERE, SMART GUY! I'M NOT WEARING ANY UNDERPANTS!

COME WITH ME TO THE OFFICE OF THIS BEING YOU CALL "BOSS", HOMER, AND I WILL REVEAL ALL!

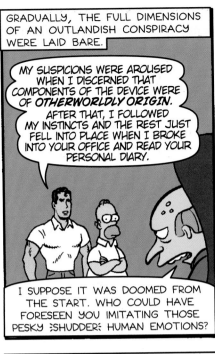
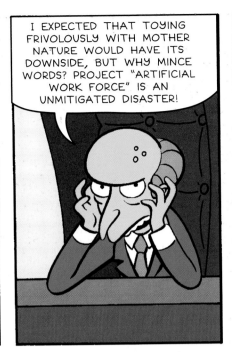
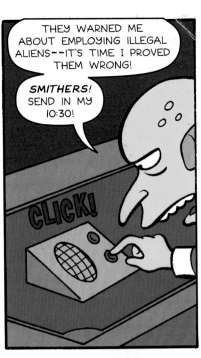
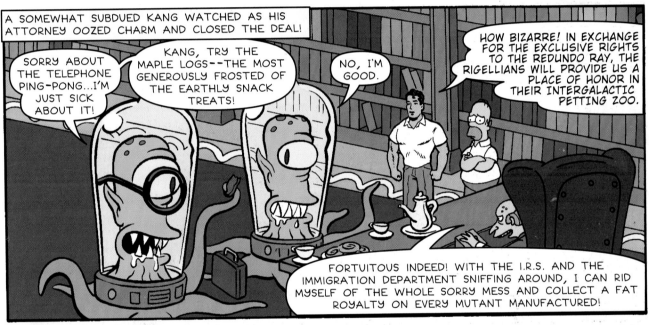
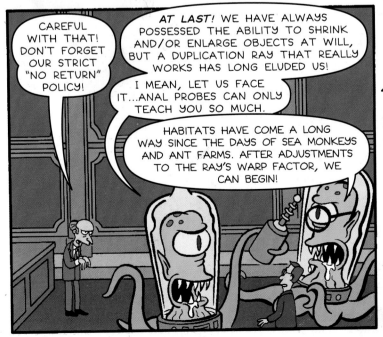
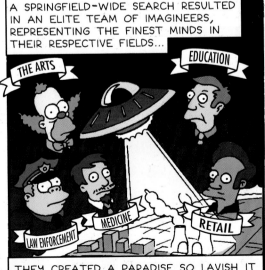

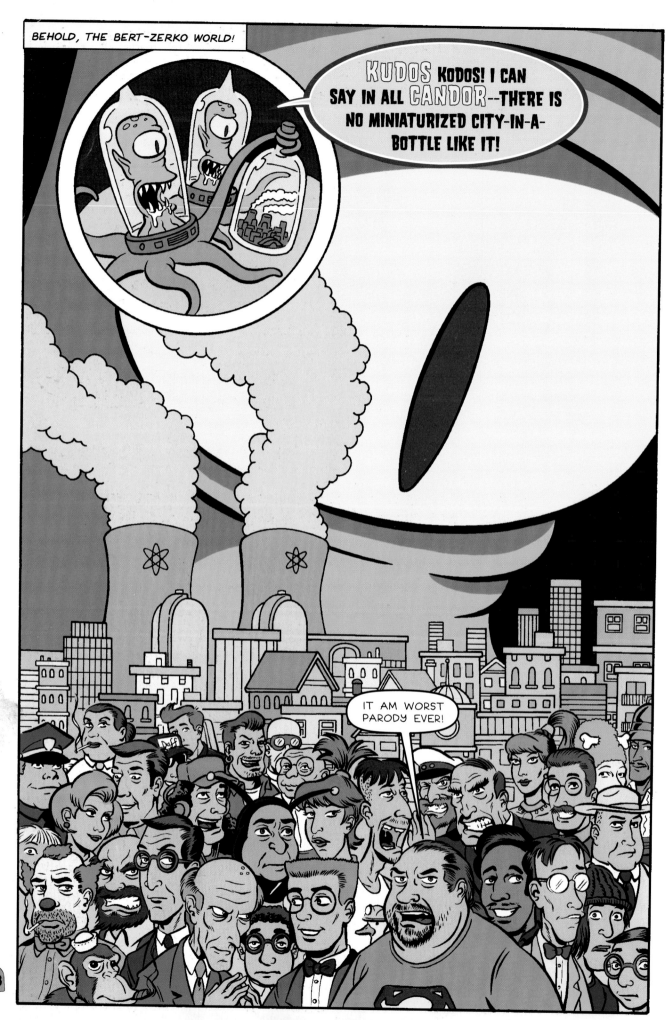

OHHH...

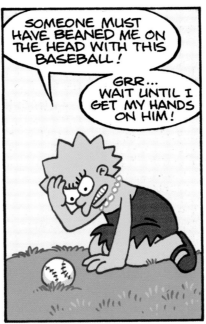

SOMEONE MUST HAVE BEANED ME ON THE HEAD WITH THIS BASEBALL!

GRR... WAIT UNTIL I GET MY HANDS ON HIM!

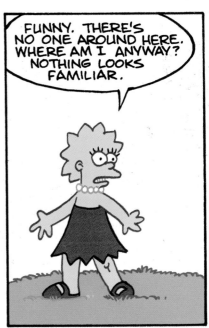

FUNNY. THERE'S NO ONE AROUND HERE. WHERE AM I ANYWAY? NOTHING LOOKS FAMILIAR.

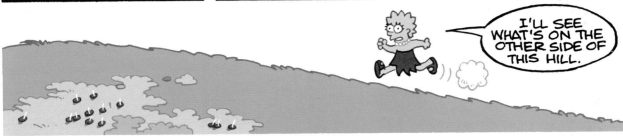

I'LL SEE WHAT'S ON THE OTHER SIDE OF THIS HILL.

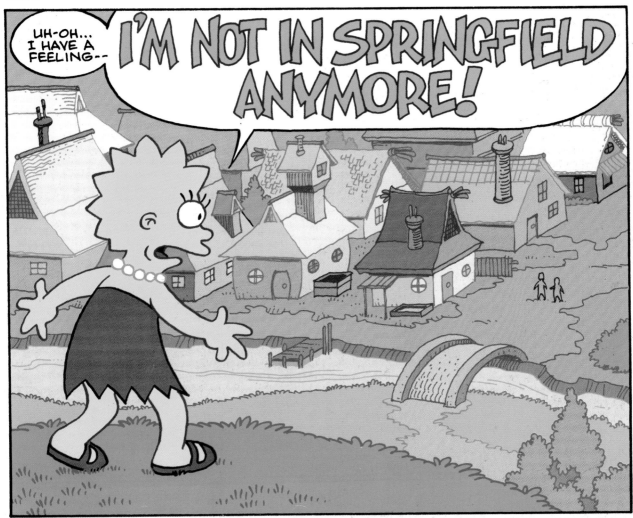

UH-OH... I HAVE A FEELING-- I'M NOT IN SPRINGFIELD ANYMORE!

STORY AND ART
STAN (BRAINLESS) SAKAI

COLORS
NATHAN (COWARDLY) KANE

EDITS
BILL (HEARTLESS) MORRISON

MUNCHKIN WRANGLER
MATT (GREAT OZ) GROENING

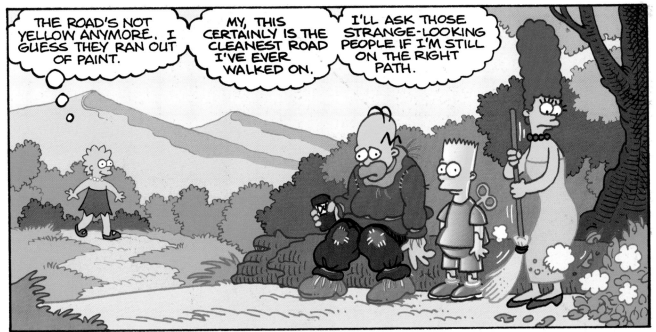

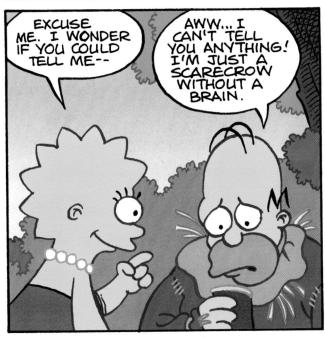

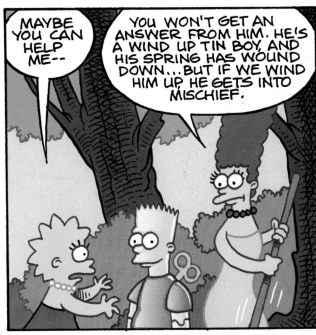

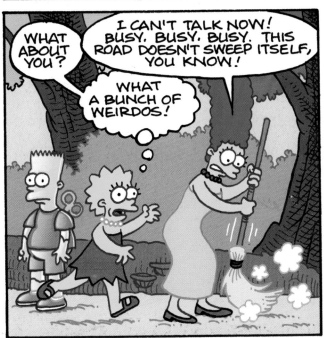

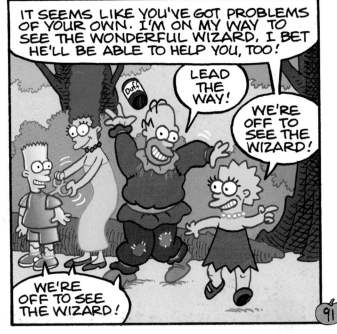

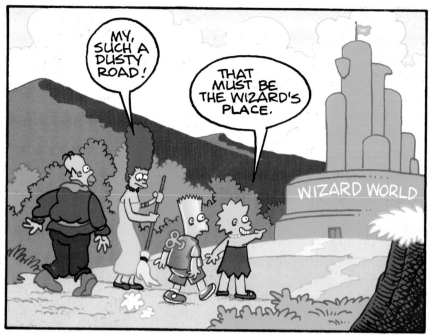

SOON...

BEHOLD! BEHIND THESE DOORS RESIDES THE GREAT AND POWERFUL WIZARD!

EL BARTO

HEY BOSS-- YOU'VE GOT VISITORS!

BID THEM ENTER MY SANCTUM SANCTORUM! HAVE THEM GROVEL BEFORE ME-- BUT DON'T SCUFF THE FLOOR.

THE WIZARD IS IN

CREEEEEAKKKKK

MAN, WE HAVE GOT TO GET SMALLER DOORS.

GO ON IN.

¡GASP!¡

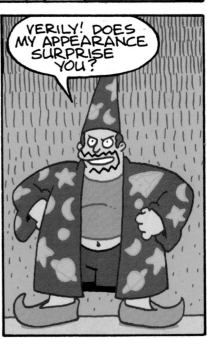

VERILY! DOES MY APPEARANCE SURPRISE YOU?

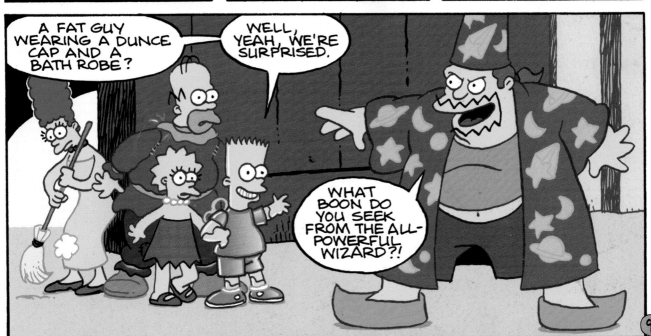

A FAT GUY WEARING A DUNCE CAP AND A BATH ROBE?

WELL, YEAH, WE'RE SURPRISED.

WHAT BOON DO YOU SEEK FROM THE ALL-POWERFUL WIZARD?!

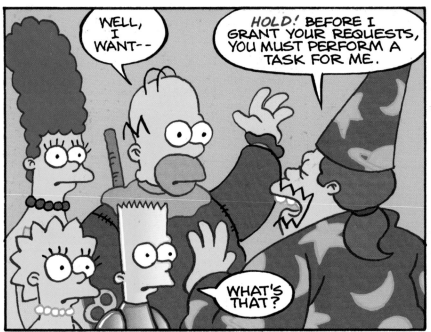

WELL, I WANT--

HOLD! BEFORE I GRANT YOUR REQUESTS, YOU MUST PERFORM A TASK FOR ME.

WHAT'S THAT?

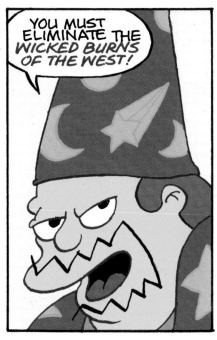

YOU MUST ELIMINATE THE *WICKED BURNS OF THE WEST!*

THAT BLACK-HEARTED SCOUNDREL HOLDS THIS ENTIRE LAND IN THRALL WITH HIS REIGN OF TERROR.

THE PEOPLE QUAKE IN HIS SHADOW AS HE SPREADS A FEAR THAT BURROWS DEEP INTO THEIR HEARTS.

AND, WORST OF ALL, THE FUMES FROM HIS NUCLEAR POWER PLANT ARE DETERIORATING MY MYLAR SNUGS. MY RADIOACTIVE MAN NUMBER ONE IS NO LONGER IN MINT CONDITION!

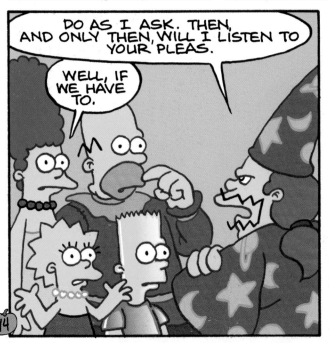

DO AS I ASK. THEN, AND ONLY THEN, WILL I LISTEN TO YOUR PLEAS.

WELL, IF WE HAVE TO.

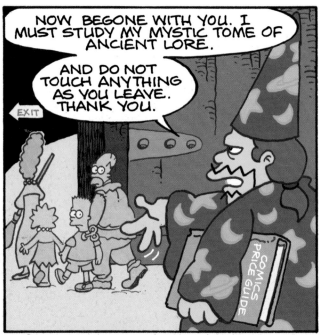

NOW BEGONE WITH YOU. I MUST STUDY MY MYSTIC TOME OF ANCIENT LORE.

AND DO NOT TOUCH ANYTHING AS YOU LEAVE. THANK YOU.

EXIT

COMICS PRICE GUIDE

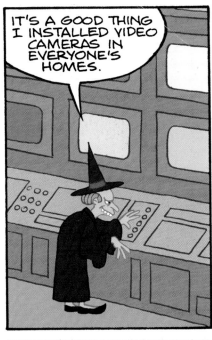

IT'S A GOOD THING I INSTALLED VIDEO CAMERAS IN EVERYONE'S HOMES.

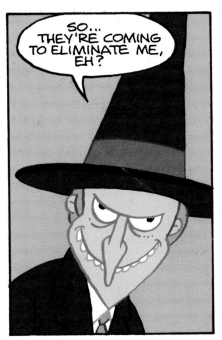

SO... THEY'RE COMING TO ELIMINATE ME, EH?

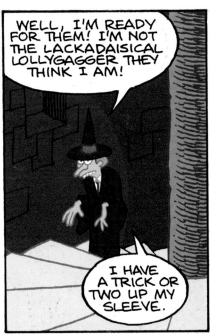

WELL, I'M READY FOR THEM! I'M NOT THE LACKADAISICAL LOLLYGAGGER THEY THINK I AM!

I HAVE A TRICK OR TWO UP MY SLEEVE.

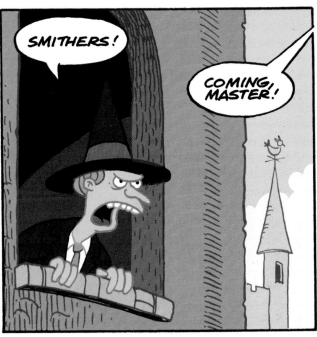

SMITHERS!

COMING, MASTER!

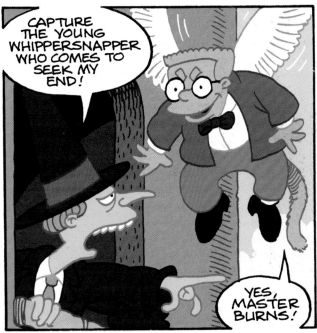

CAPTURE THE YOUNG WHIPPERSNAPPER WHO COMES TO SEEK MY END!

YES, MASTER BURNS!

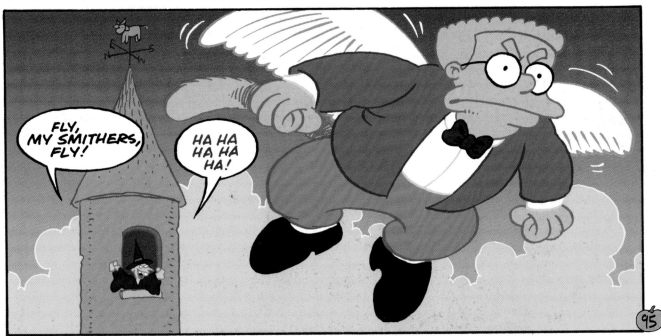

FLY, MY SMITHERS, FLY!

HA HA HA HA HA!

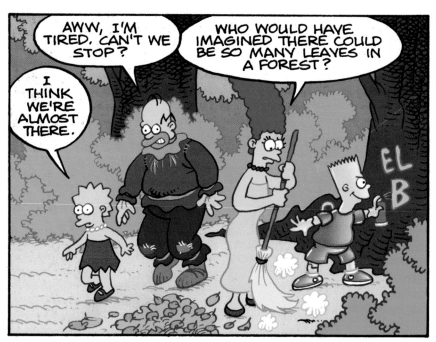

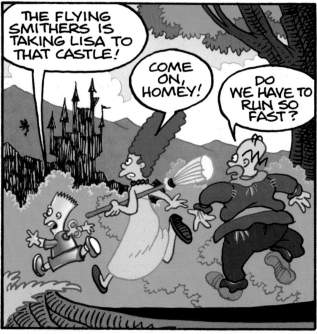

YO, JIMBO!

UH... YEAH?

THE BOSS SAID STRANGERS ARE COMING OVER SO BE ON YOUR TOES.

UH... OKAY.

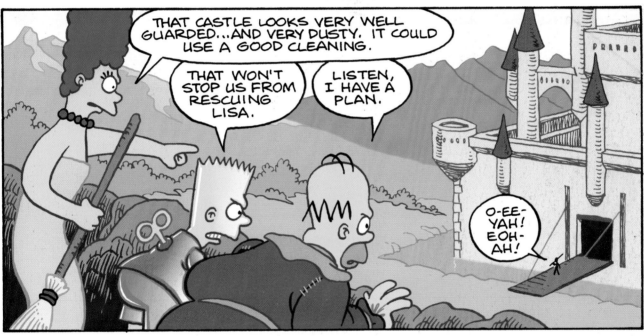

THAT CASTLE LOOKS VERY WELL GUARDED...AND VERY DUSTY. IT COULD USE A GOOD CLEANING.

THAT WON'T STOP US FROM RESCUING LISA.

LISTEN, I HAVE A PLAN.

O-EE-YAH! EOH-AH!

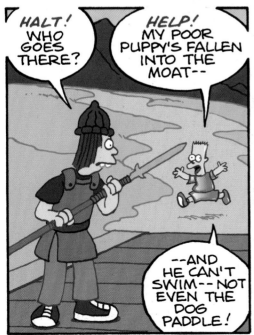

HALT! WHO GOES THERE?

HELP! MY POOR PUPPY'S FALLEN INTO THE MOAT--

--AND HE CAN'T SWIM-- NOT EVEN THE DOG PADDLE!

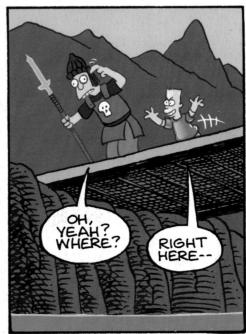

OH, YEAH? WHERE?

RIGHT HERE--

--SUCKER!

SPLASH!

CALL OUT THE GUARDS! THE CASTLE'S UNDER ATTACK!

WHAP!

OH MY, WHAT A MESS! I'D BETTER SWEEP UP.

CLEAN UP LATER, MARGE! WE'RE OFF TO RESCUE LISA!

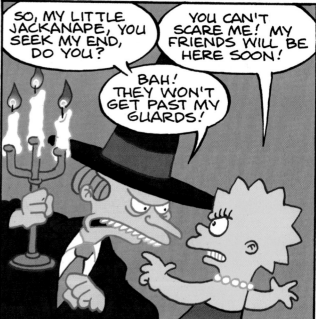

SO, MY LITTLE JACKANAPE, YOU SEEK MY END, DO YOU?

YOU CAN'T SCARE ME! MY FRIENDS WILL BE HERE SOON!

BAH! THEY WON'T GET PAST MY GUARDS!

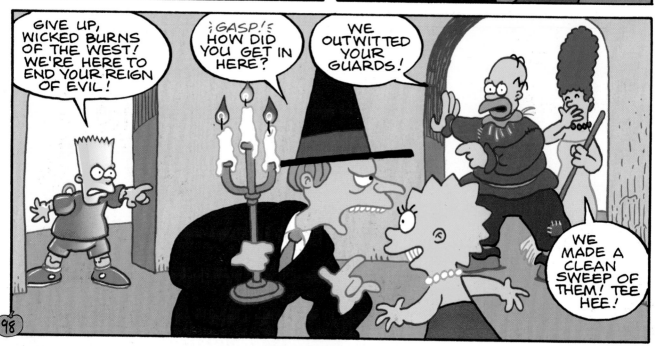

GIVE UP, WICKED BURNS OF THE WEST! WE'RE HERE TO END YOUR REIGN OF EVIL!

¡GASP!¡ HOW DID YOU GET IN HERE?

WE OUTWITTED YOUR GUARDS!

WE MADE A CLEAN SWEEP OF THEM! TEE HEE!

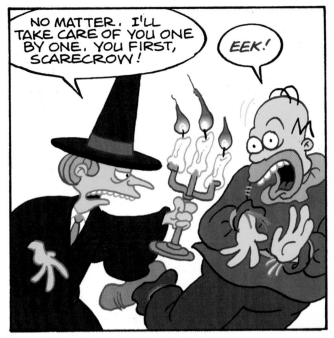

NO MATTER. I'LL TAKE CARE OF YOU ONE BY ONE. YOU FIRST, SCARECROW!

EEK!

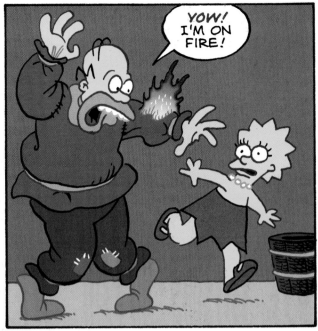

YOW! I'M ON FIRE!

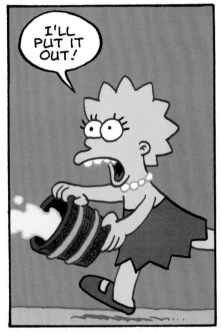

I'LL PUT IT OUT!

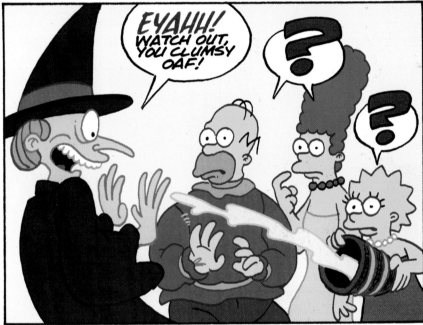

EYAHH! WATCH OUT, YOU CLUMSY OAF!

?

?

OH, NO!

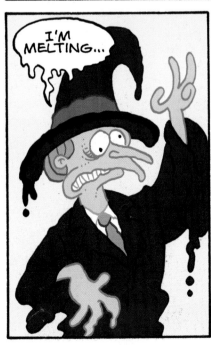

I'M MELTING...

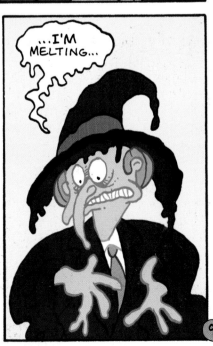

...I'M MELTING...

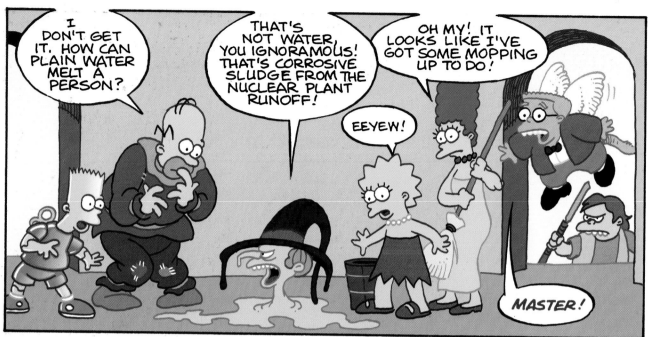

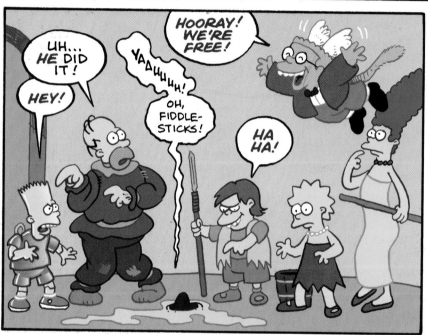

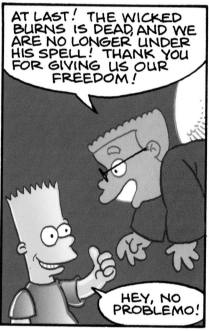

EXCUSE ME BUT I COULDN'T HELP OVERHEARING, WHAT WITH YOUR LOUD VOICES AND ALL.

QUIET, YOU. YOU ARE HERE TO REPAIR MY DEHUMIDIFIER! MY COMIC COLLECTION IS MOLDING EVEN AS WE SPEAK!

BUT I CAN REMEDY YOUR PROBLEMS. MARGE, ALL YOU NEED IS SOME EFFICIENCY. THROW AWAY THAT BROOM! HERE'S A NEW VACUUM CLEANER!

I CAN HIRE MYSELF OUT AS A MAID SERVICE WITH THIS BABY!

BOY, THAT THING REALLY SUCKS!

VRRRRRR

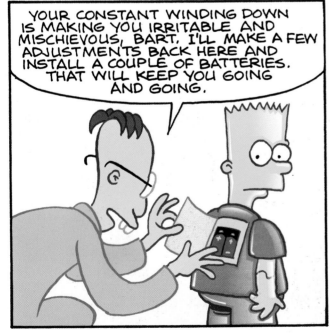

YOUR CONSTANT WINDING DOWN IS MAKING YOU IRRITABLE AND MISCHIEVOUS, BART. I'LL MAKE A FEW ADJUSTMENTS BACK HERE AND INSTALL A COUPLE OF BATTERIES. THAT WILL KEEP YOU GOING AND GOING.

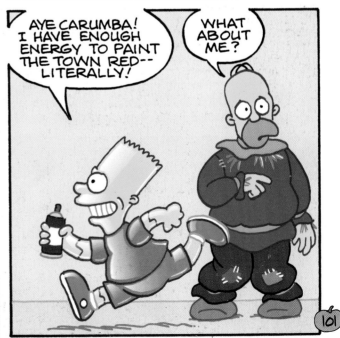

AYE CARUMBA! I HAVE ENOUGH ENERGY TO PAINT THE TOWN RED-- LITERALLY!

WHAT ABOUT ME?

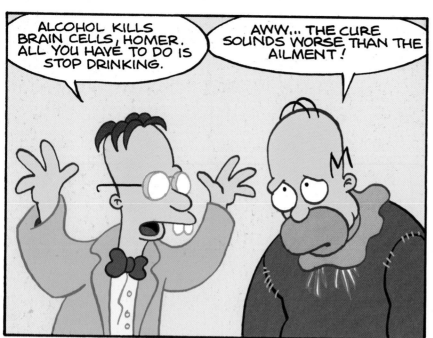

ALCOHOL KILLS BRAIN CELLS, HOMER. ALL YOU HAVE TO DO IS STOP DRINKING.

AWW... THE CURE SOUNDS WORSE THAN THE AILMENT!

I'M GLAD YOU WERE ABLE TO HELP THEM BUT CAN YOU HELP *ME*? I WANT TO GO BACK TO MY OWN HOME AND MY OWN FAMILY.

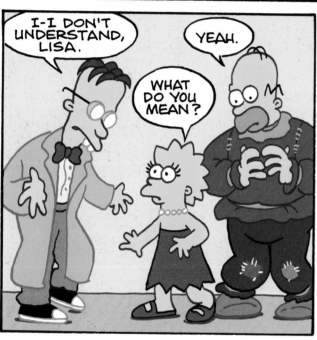

I-I DON'T UNDERSTAND, LISA.

YEAH.

WHAT DO YOU MEAN?

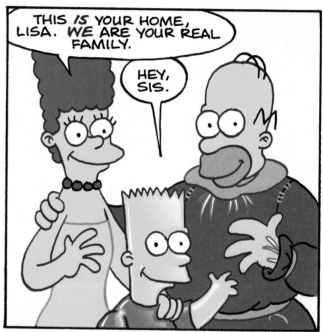

THIS *IS* YOUR HOME, LISA. *WE* ARE YOUR REAL FAMILY.

HEY, SIS.

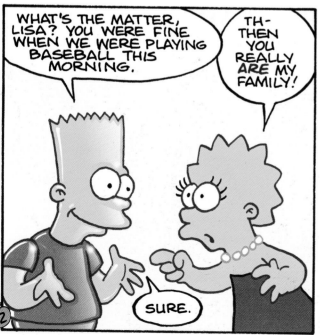

WHAT'S THE MATTER, LISA? YOU WERE FINE WHEN WE WERE PLAYING BASEBALL THIS MORNING.

TH- THEN YOU REALLY ARE MY FAMILY!

SURE.

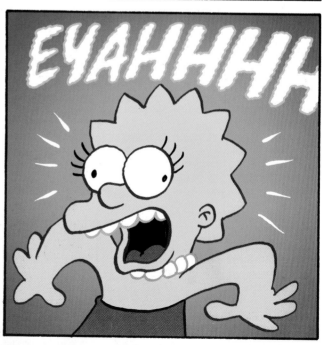

EYAHHHH

102

YAHHHH

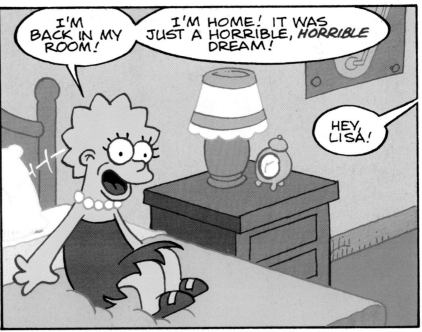

I'M BACK IN MY ROOM!

I'M HOME! IT WAS JUST A HORRIBLE, *HORRIBLE* DREAM!

HEY, LISA!

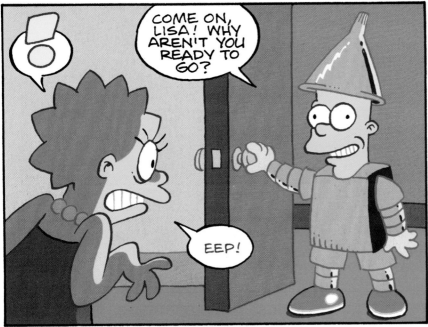

COME ON, LISA! WHY AREN'T YOU READY TO GO?

EEP!

OOOHH...

PLOP!

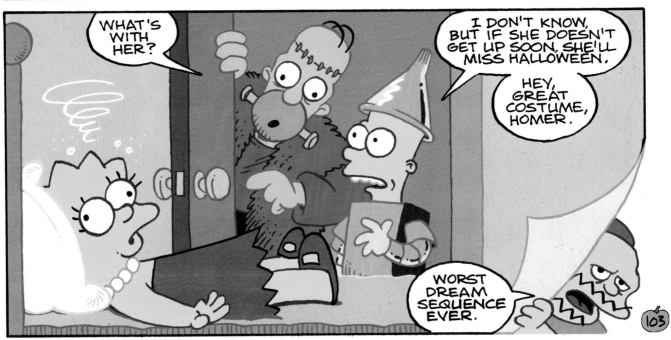

WHAT'S WITH HER?

I DON'T KNOW, BUT IF SHE DOESN'T GET UP SOON, SHE'LL MISS HALLOWEEN.

HEY, GREAT COSTUME, HOMER.

WORST DREAM SEQUENCE EVER.

103

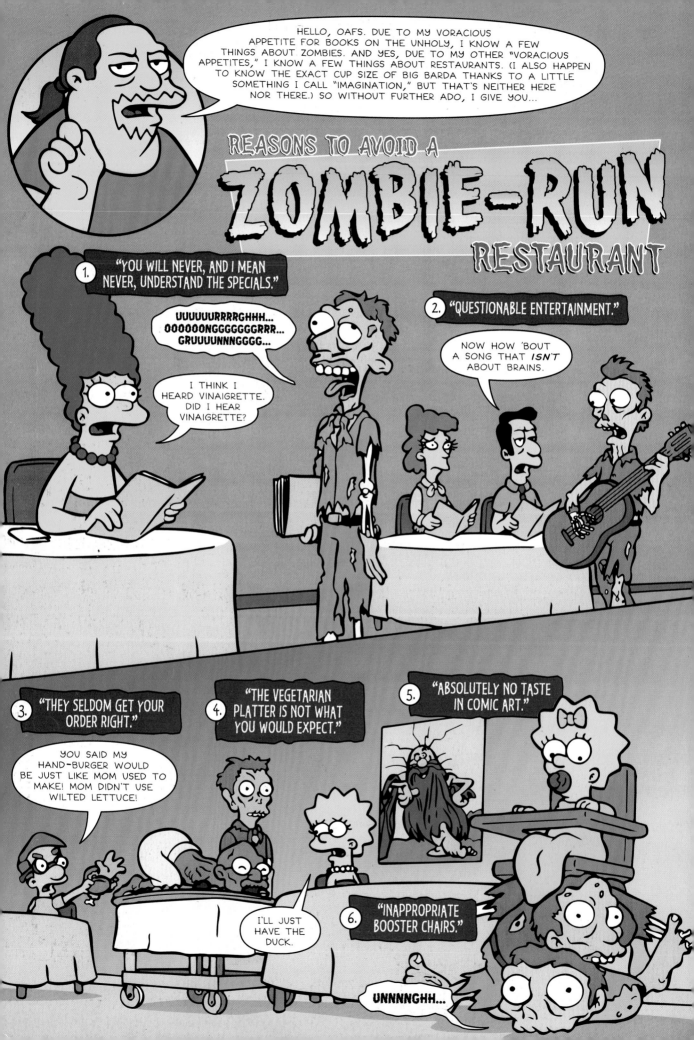

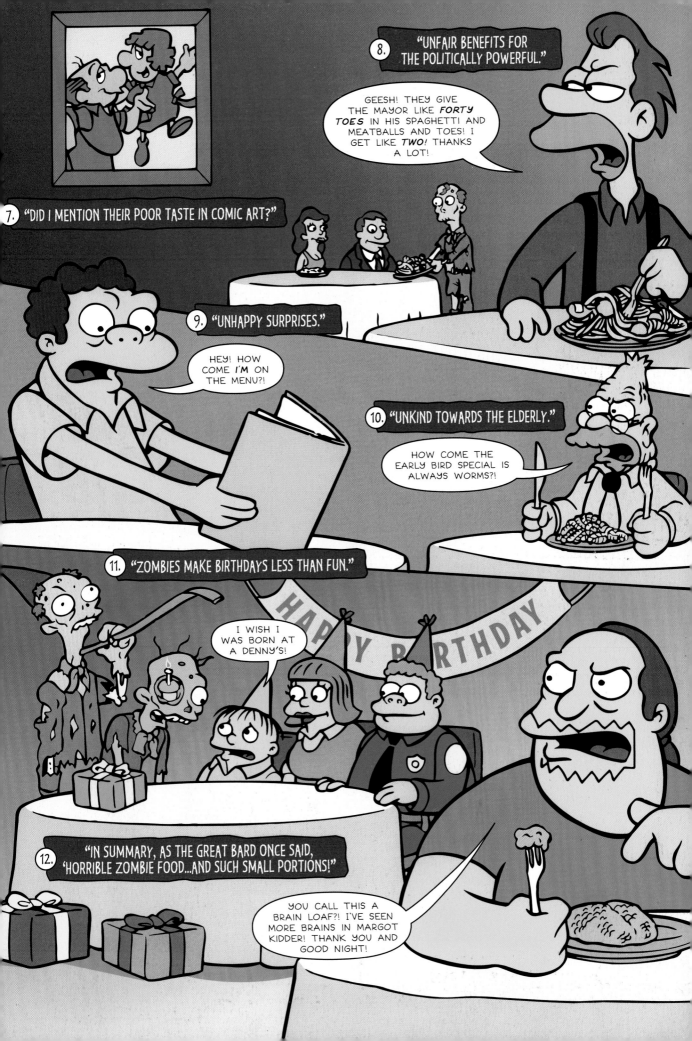

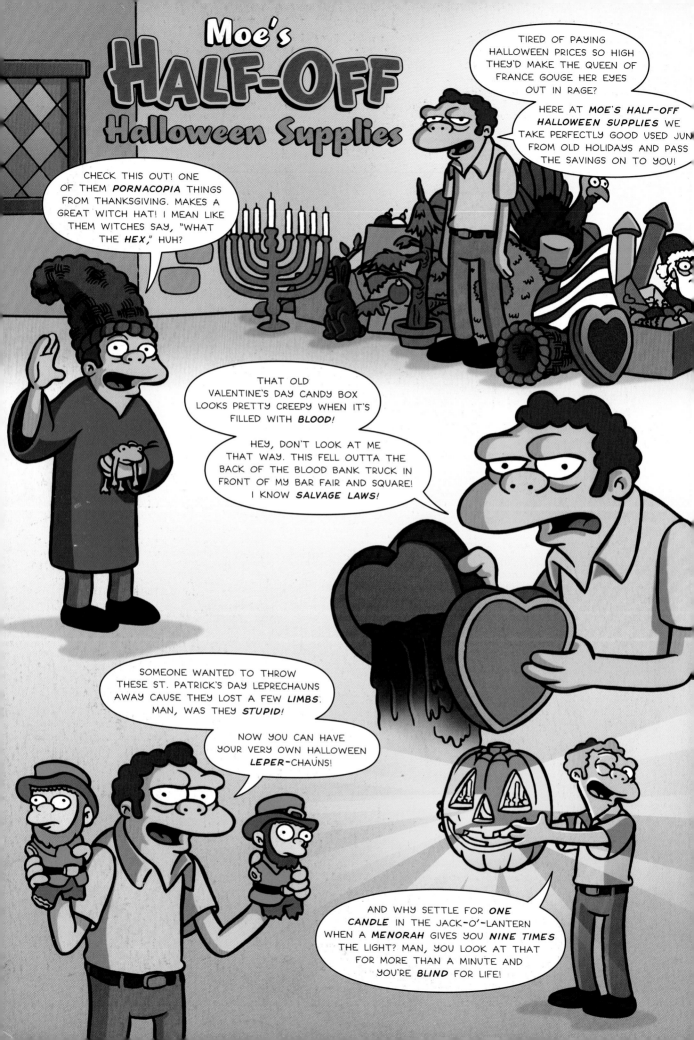

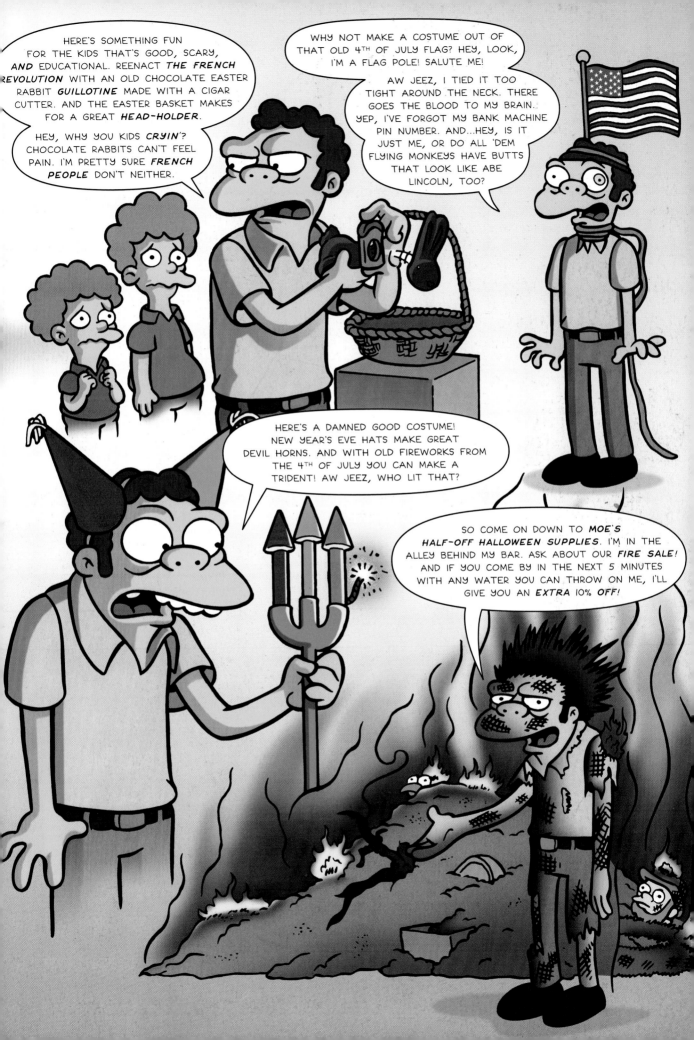

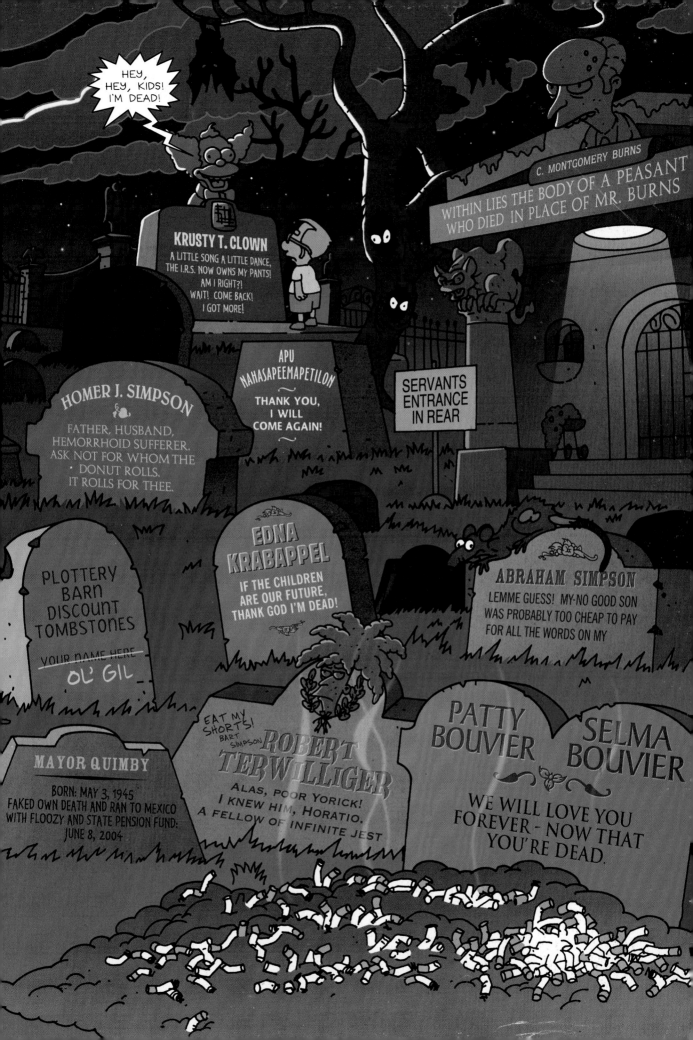

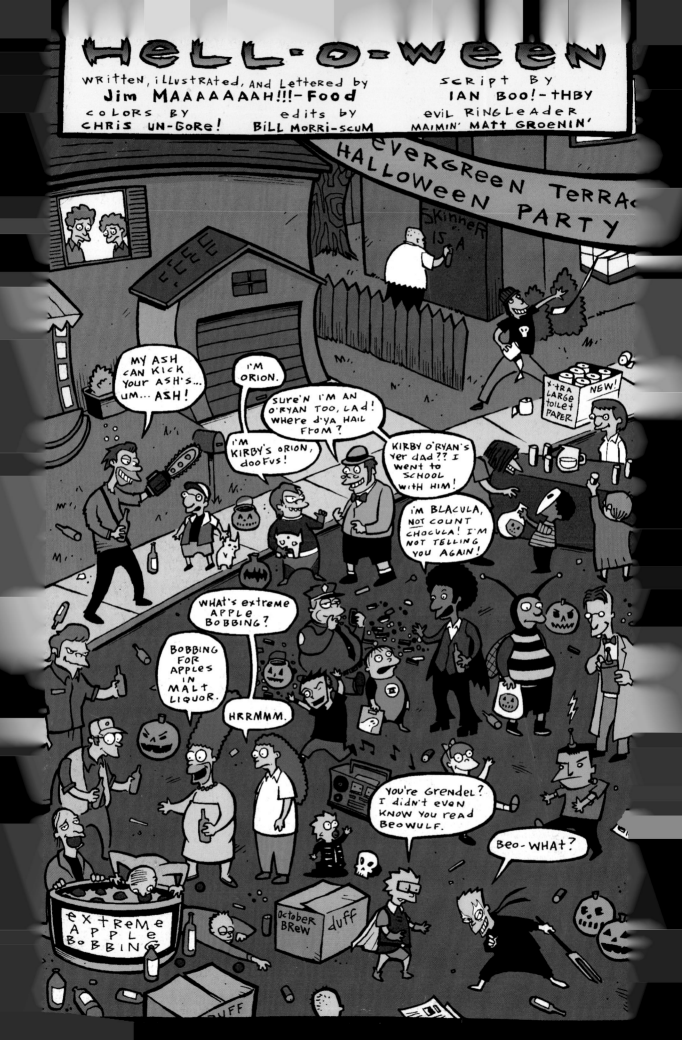

daddy, CAN we go to the HALLOWEEN PARTY?

NO CAN diddley-do, BOYS. TOO MUCH SUGAR AND SACRILEGE.

BUT WE'RE BORED.

SORRY, but I'd RATHER be BLAH +HAN BLASPHEMOUS!

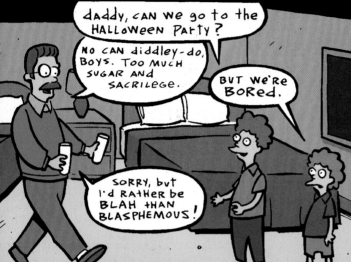

You See Rod, Todd. HALLOWEEN is the one time of the year where you NEVER KNOW WHAT twisted EVIL the deVIL is planning...

yes! yes!! it's the PeRFect PLAN!!

B-10!

YOU SANK MY BATTLeSHIP!!

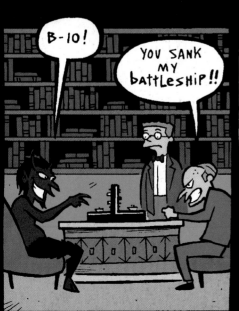

SAY, NICK, OLD boy. you seem down. NORMALLY OUR THURSDAY GAME Night cheers you RIGHT uP!

I've just been WORKING... ⸮YAWN⸮ overtime lately.

CAN i Get you ANYTHING?

coFFee? BRANDY? SMITHeR'S SOUL?

I HAVE too MANY SOULS ALREADY, AND they'Re ALL the SAME. They BORE me.

MAYbe you Need to diveRSIFY. BRANCH out. BRING in dog's SOULS OR SAY.... CHILDReN.

It MIGHT be NICE to HAVE some KIDS AROUND, BUT WE'Re Not Allowed to ReCRUIT CHILDReN...

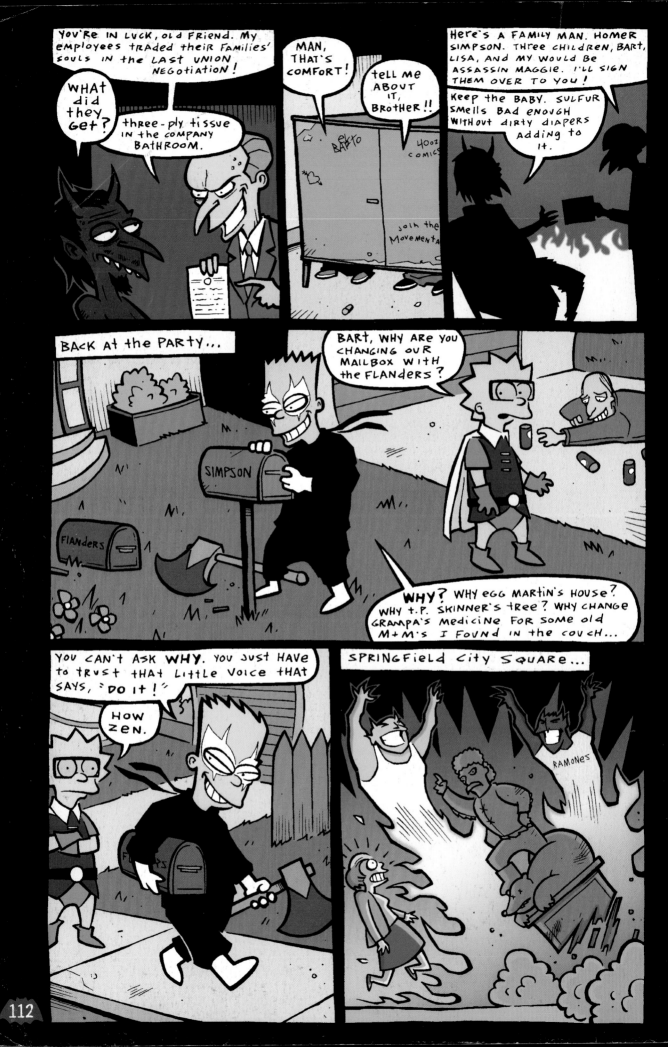

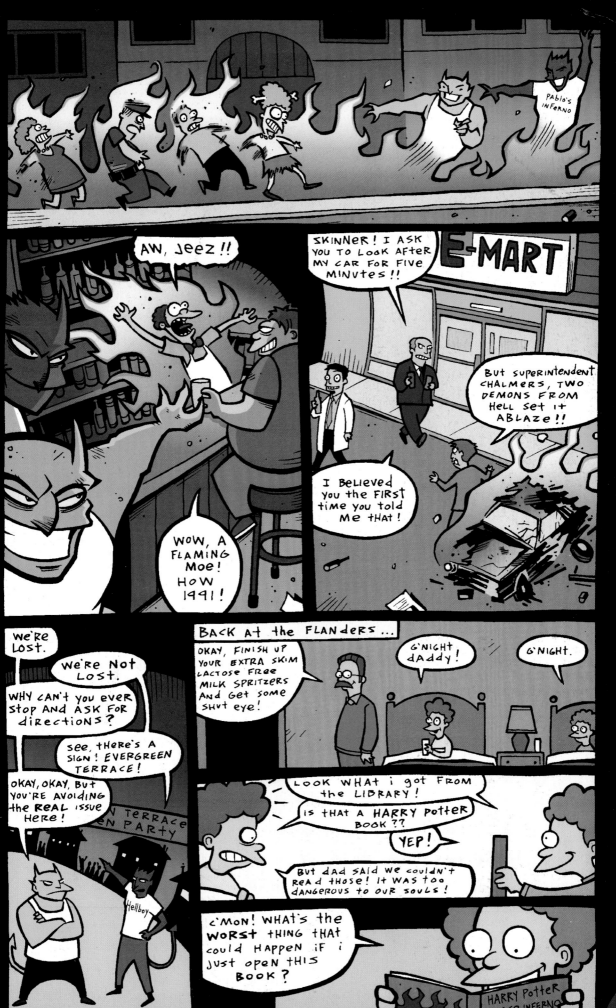

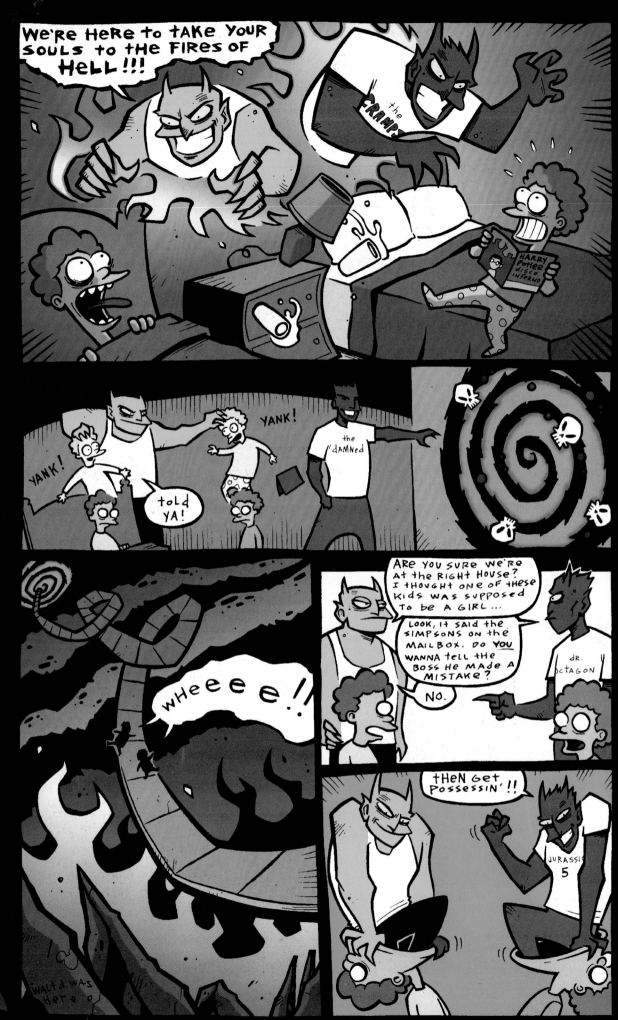

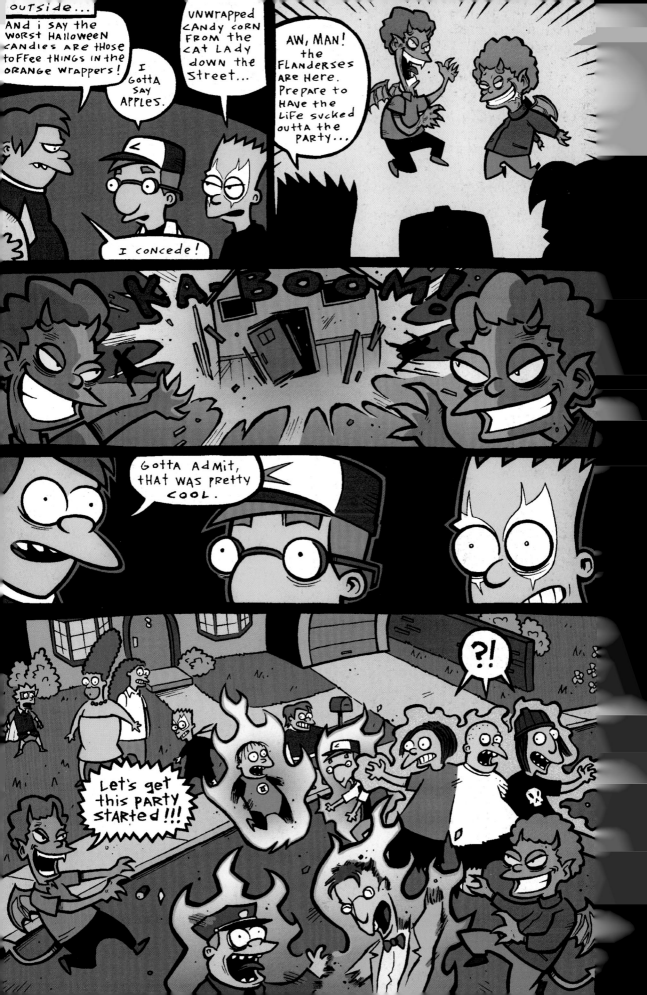

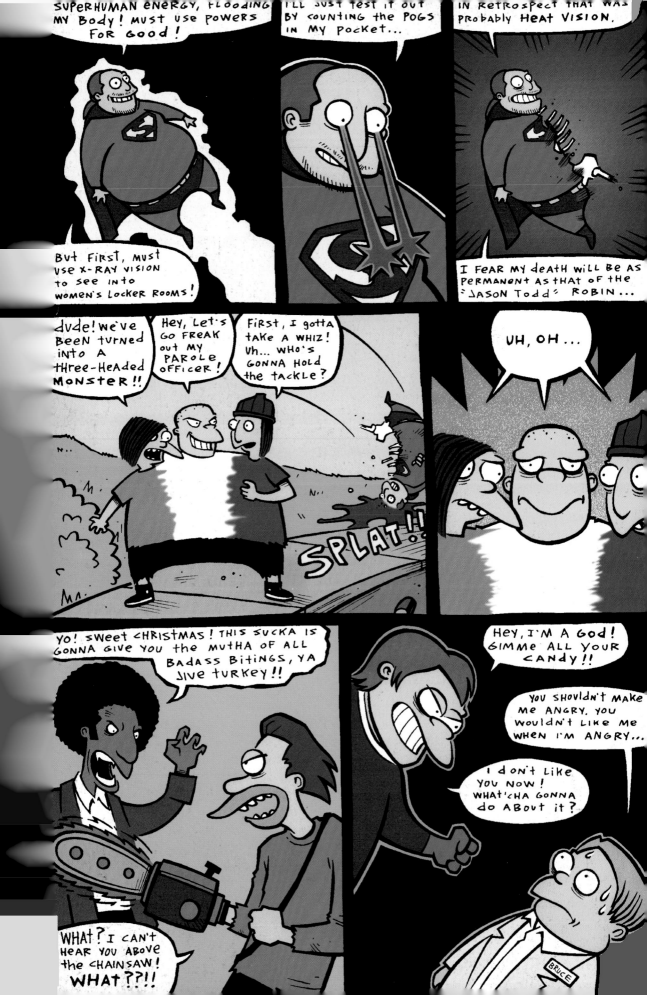

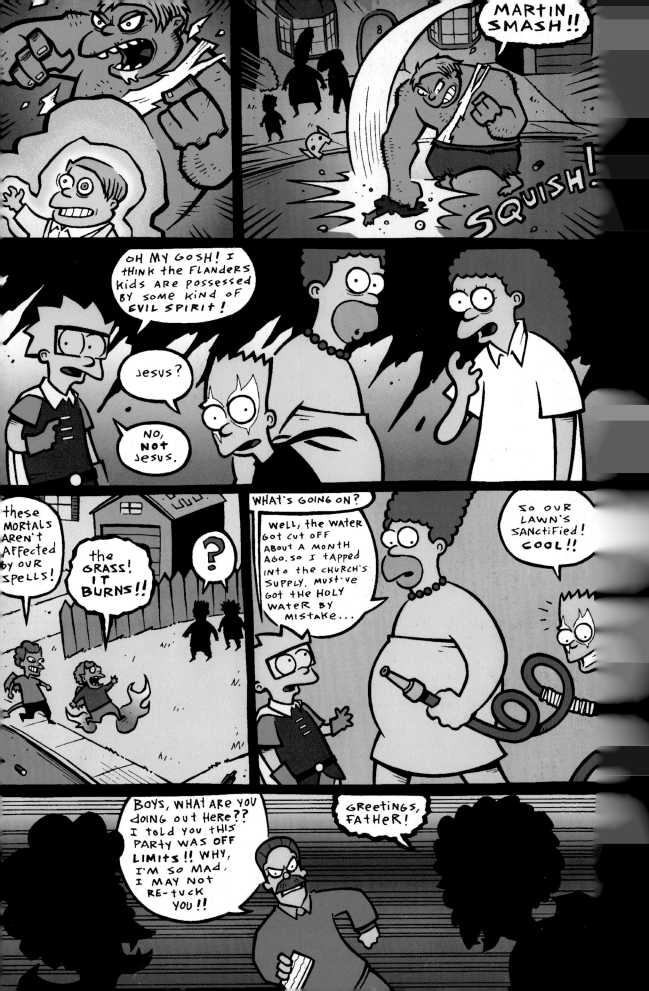

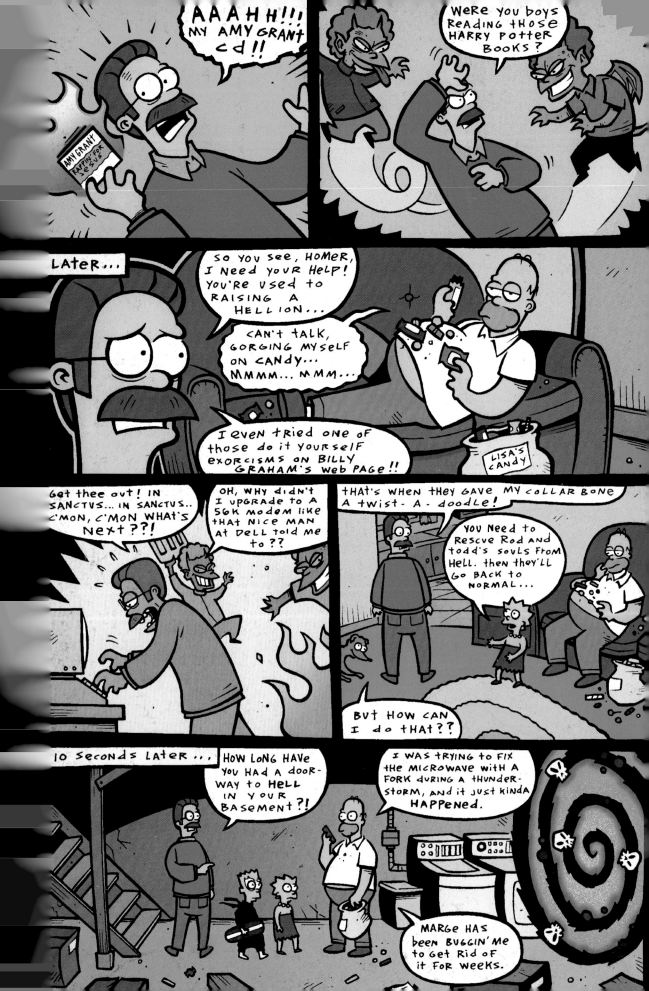

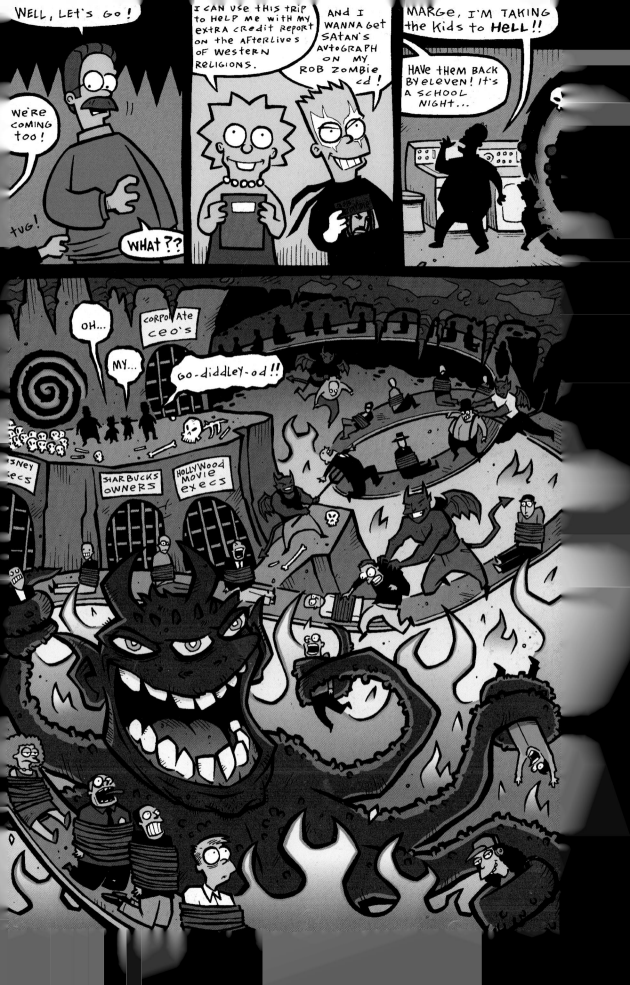

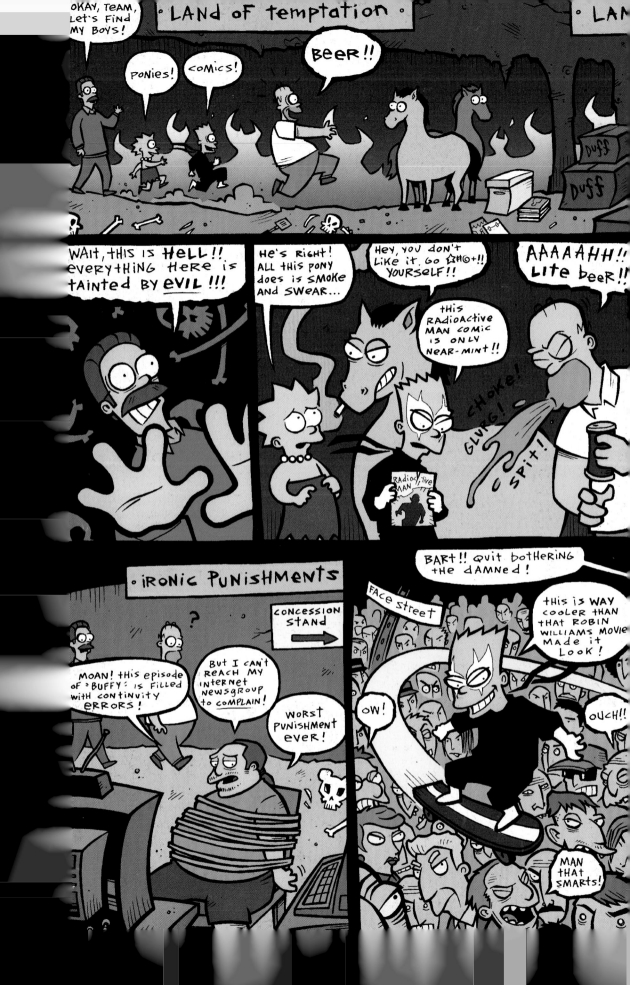

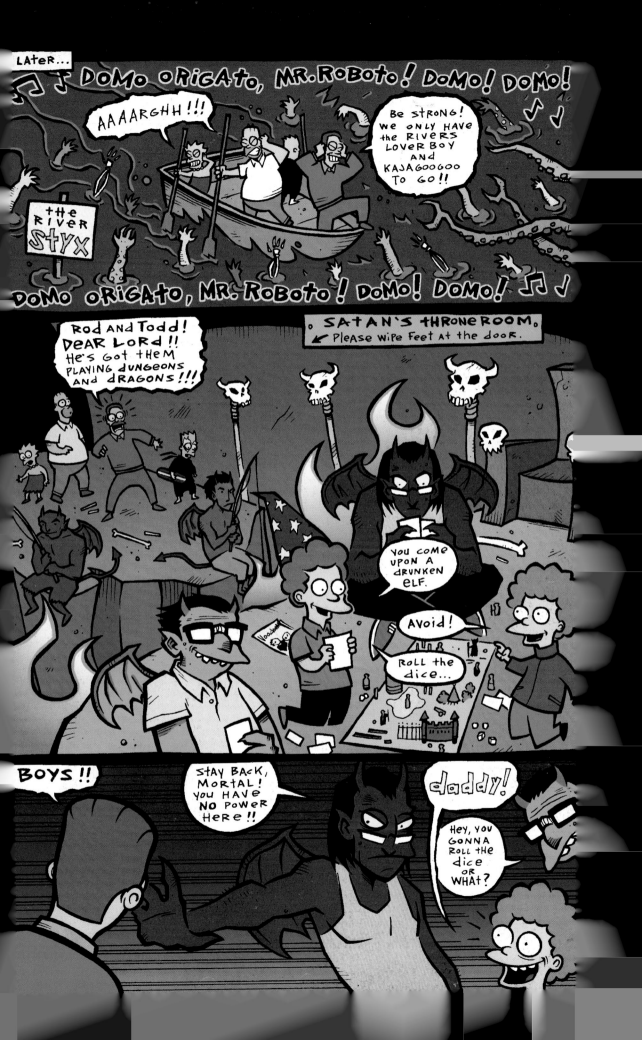

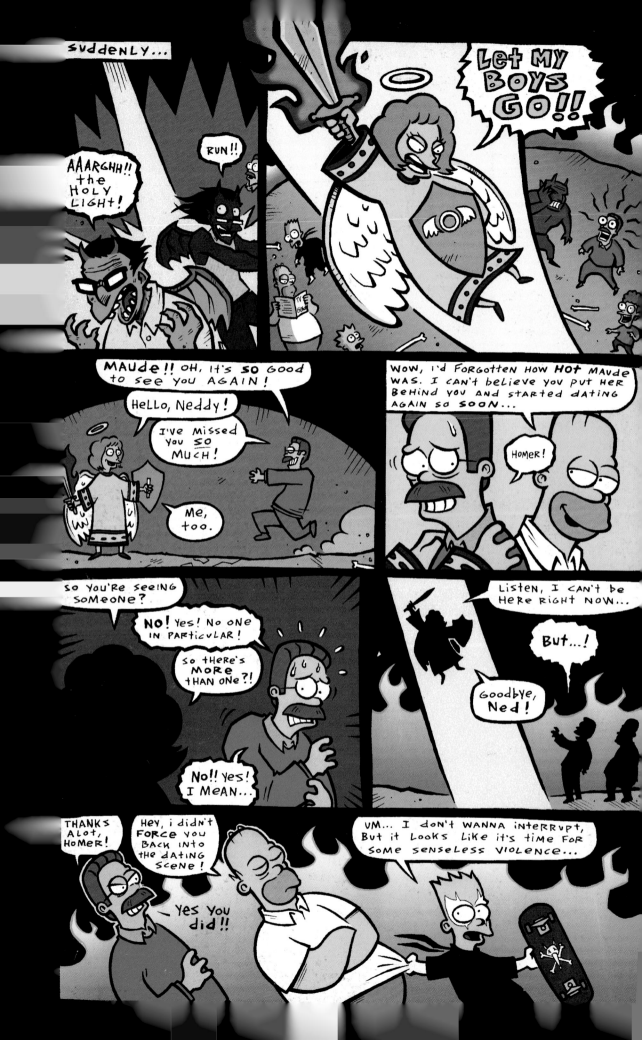

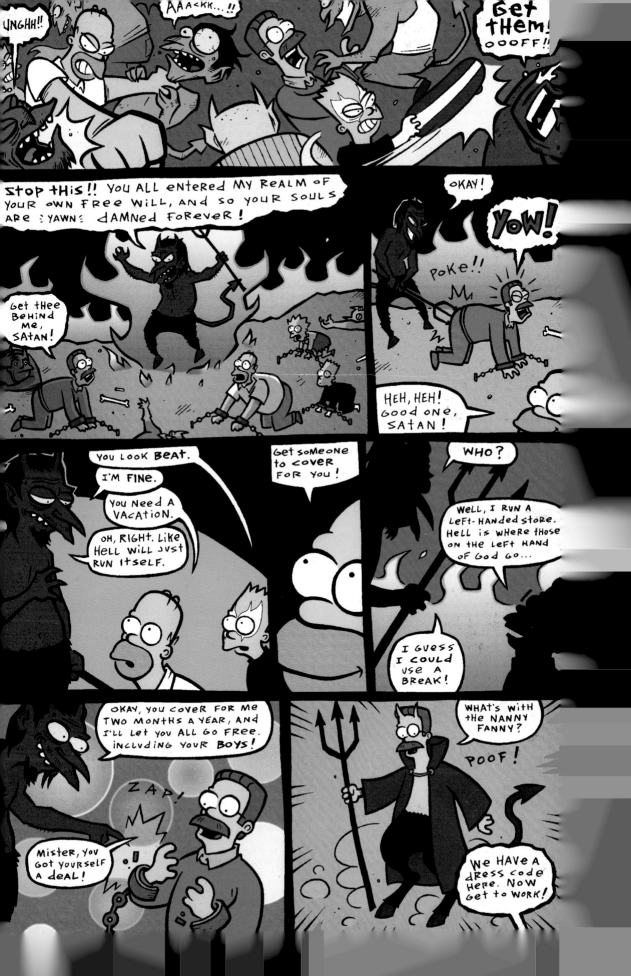

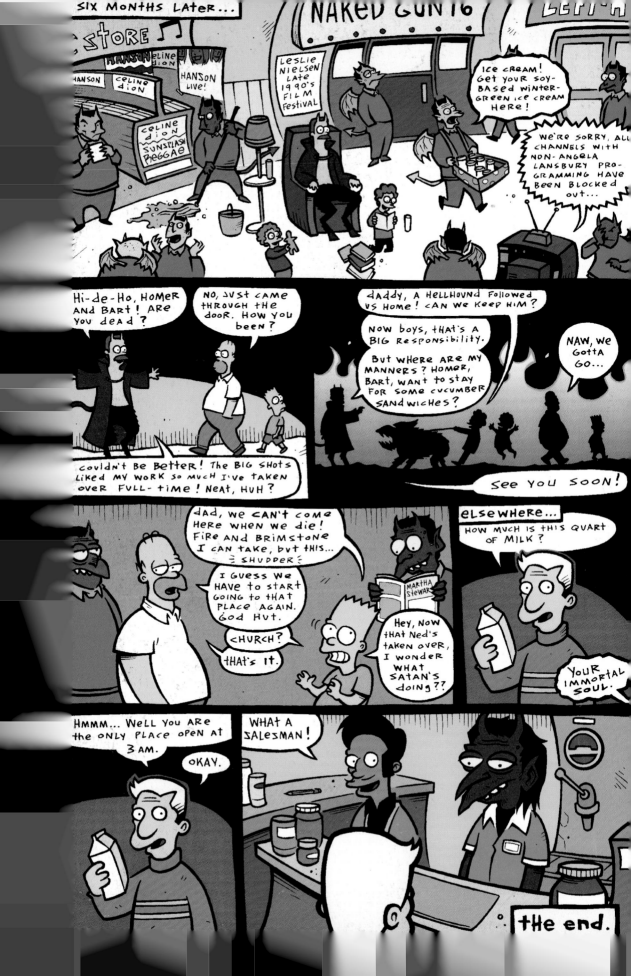